IMAGES
of America

THREE LAKES

Peggy,

We don't see each other nearly enough but I am always so thankful when we are able to spend time together.

I hope you enjoy the book!

Alan

IMAGES
of America

THREE LAKES

Alan Tulppo and Kyle McMahon
on behalf of the Three Lakes Historical Society

ARCADIA
PUBLISHING

Published by Arcadia Publishing
Charleston, South Carolina

Printed in the United States of America

Library of Congress Control Number: 2013914408

For all general information, please contact Arcadia Publishing:
Telephone 843-853-2070
Fax 843-853-0044
E-mail sales@arcadiapublishing.com
For customer service and orders:
Toll-Free 1-888-313-2665

Visit us on the Internet at www.arcadiapublishing.com

CONTENTS

ACKNOWLEDGMENTS

We would like to thank the Three Lakes Historical Society board for supporting us in this project, especially those who were generous with their time and historical knowledge. Joan Meeder and our volunteer docents at the museum, especially Bill Schliep, Barb Lindquist, Corrine Lester, Karen Littleton, and Jan Hintz, assisted in the creation of this book by locating images and related information in our archives. In addition to our volunteer docents, we wish to express our appreciation to Erica Brewster, Bill and Peggy Hayes, Mary Hitchcock, and Tom Rulsch for providing editorial and proofreading assistance.

Many people have been generous with their time and historical knowledge. We are grateful for the help of Nancy Brewster for her assistance with locating images that we needed to more accurately tell the town's story, and Jean Dick, who provided us with valuable information about the resort industry in Three Lakes.

Numerous other people, including Maryanne Anderson, Cynthia Motylewski Lake, John Lake, Eugene Ohm, Gene Step, Dave and Jan Hintz, Bob Zembinski, Karen Connolly Miller, Lois Ralph, and Judy Block, have shared images and information for this book.

Some of our sources include *Pine, Plow and Pioneer* (1983) by the Three Lakes Historical Society, *80 Years in God's Country* (1972) by Edward H. Epler, *Three Lakes News, Vilas County News-Review,* and *Oneida County History: Centennial Edition 1887–1987* by Patricia Friebert and Dorothy Guilday.

INTRODUCTION

The history of any community or region is based on stories shared by individuals, official documents and records, and the work of historians. We hope that this book provides the reader with a clear and true version of the history of our community.

The Lake Shore Traffic Railroad Company purchased the Three Lakes area from the US government on July 15, 1881. The railroad bought every other section of land on each side of the right-of-way for a distance of 60 miles, from Monico, Wisconsin, to Watersmeet, Michigan. In turn, the railroad sold the timber to lumber companies to offset expenses. The area was later sold to the Milwaukee Lake Shore & Western Railroad in 1884, and finally to the Chicago & Northwestern Railroad in 1893.

The arrival of the railroad in this region brought with it settlers and the use of the land and natural resources for economic development, agriculture, and recreational purposes. It is important to note that the first settlers did not arrive by rail. Well before the arrival of the railroad and the lumberman, the Chippewa and Potawatomi Indians, who led a life based upon subsistence agriculture, trade, fishing, and hunting, inhabited this area. Native Americans traveled the area, canoeing in the many lakes and establishing woodland trails, which in many cases became the routes of our current roads. Records indicate that the earliest trading post began around 1860 and was established by Hiram Benjamin "Hi" Polar, near present-day Virgin Lake. The trading post was a frequent stopover for men who carried mail from Green Bay, Wisconsin, over the Military Road to Ontonagon, Michigan. The arrival of the railroad and lumbermen greatly altered their way of life in this region.

The first era in the history of Three Lakes involved the railroad and logging industries, and much of the early history of our community is directly tied to the railroad. When the railroad surveyors and lumbermen, who wanted to establish supply stations close to their timber, arrived here, they encountered a series of three lakes. According to Edward H. Epler in *80 Years in God's Country*, "the first lake the surveyors encountered was surrounded by virgin maple timber. They named it Maple Lake. The next lake near it was crossed by the surveyed town line, and so they named it Townline Lake. Since the range line ran along the west side of another lake, the surveyors named it Range Line Lake. With these three lakes in mind, they named the supply station location, 'Three Lakes.' " With this seemingly inauspicious beginning, the community of Three Lakes was born. The main street was dirt, and the sidewalks were made of boards.

After the area had been heavily logged during the boom and only smaller operations remained, there was a need for a source of economic activity to support the residents of the region. From the end of the logging boom era to around 1941, Three Lakes experienced a growth in farming. People turned to agriculture to make a living. To many, farming seemed like an obvious choice because the land was already cleared. Initially, farmers attempted to raise a variety of different crops; however, few proved to be viable enough to provide farmers with a steady income to support themselves and their families. The two crops that proved successful in this region were potatoes and, later, cranberries. Both of these crops have continued to be a staple of the agricultural industry in the region in the 20th and 21st centuries.

Along with the growth in agriculture, the natural appeal of the region, including its chain of 28 lakes, for recreational activities drew people from urban areas in search of an escape from life in the city. Records indicate that as early as 1885, the area began to attract groups of wealthy

sportsmen. As they began to visit the area with more frequency throughout the late 1800s and early 1900s, a new industry catering to tourists developed in Three Lakes. In 1887, sportsmen from near Batavia, Illinois, arrived in Three Lakes and camped on Charley French's Island, which is now commonly known as Denby Island. In 1898, this group later purchased the property that is currently occupied by the Rod and Gun Club. These men were followed by numerous others, and their presence in the community created a demand for services such as groceries, construction, medical care, churches, and schools to educate the children of the year-round residents.

The Chicago & Northwestern Railroad, seeking to attract new business to its passenger service, promoted the area in its advertising, and this resulted in the growth of tourism to Three Lakes and the development of the resort industry. The Fisherman's Special was an overnight train that brought sportsmen from the Chicago and Milwaukee areas to Three Lakes for fishing weekends. Records indicate that the first resorts began operating in Three Lakes around 1890 and the first light-housekeeping resort opened around 1912.

The year 1912 was also the beginning of the youth summer camp era in the region. The first summer camp to open was Camp Idyle Wyld for girls, established by Leo and Feicitas (née Saleski) Bishop. The camp was located on Townline Lake and was operated until Leo Bishop was killed in an auto accident in Chicago while on camp business. Camp Minne Wonka for boys began on Virgin Lake and was operated by Dr. and Mrs. Frank Ewerhardt. They ran the camp for many years, and later sold it to Ruth Becker, who changed the name to O-Than-Agon and converted it to a camp for girls. In 1917, Leslie and Viola Lyon came from St. Louis to the Three Lakes area to work as counselors at Camp Minne Wonka. They later opened a sister camp for girls on Little Fork Lake in the summer of 1921; it was named Minne Wonka Lodge. They sold the camp in 1965, and it operated until 1983, when it was sold and subdivided into lots. Many of the buildings still stand today. Through the years, numerous camps were established around Three Lakes, such as Camp St. Mary and St. George of Clearwater Lake, Camp Luther, and Ray Meyers Basketball Camp.

The years 1920 through the 1950s saw many changes for Three Lakes. Along with the development of summer camps, the resort industry, and potato farming, the Civilian Conservation Corps played an integral role in revitalizing the region's natural resources, thus enhancing the area's scenic beauty and appeal. The war years of the 1940s saw many men and women from Three Lakes volunteer in service to their country. The introduction of cranberry farming in the 1940s by Ralph Samson and Vernon Goldsworthy brought further economic activity and notoriety to the region. During the 1950s, the resort and camp industries continued to play important roles in the community, and the citizens of Three Lakes continued to invest in their public schools by supporting building projects and expanding curricular offerings. Churches and other civic organizations also grew and played a role in supporting the vitality and growth of the town.

This is, of course, only a part of the Three Lakes story. The community has continued to grow and change over the past several decades. At the time of the Three Lakes Centennial in 1981, the residents celebrated with a yearlong festival that featured multiple parades, fireworks displays, dances, ethnic festivals, the opening of a centennial museum, and a concert featuring Barbara Mandrell, who had been a recent "entertainer of the year." The town's seasonal and year-round citizens continue to demonstrate civic pride in their community through their involvement in organizations such as the Lions Club, the American Legion, the Three Lakes Center for the Arts, the Three Lakes Historical Society and Museum, and the Three Lakes Women's Club, and their support of their churches, schools, and local library. Of course, these are only a handful of organizations in which the residents of our community are active. A further testament to the involvement and pride the residents have in their community is the fact that Kraft Foods honored Three Lakes as "the Single Best Town in America" in 2010.

The Three Lakes story has many more chapters to be written in the years ahead. The people who call this area home, through their contributions to their town, will do the writing.

One

LOGGING AND RAILROADS

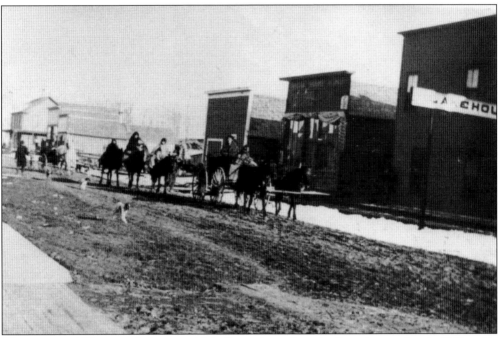

This picture of Chippewa Indians on Main Street (now Superior Street) was taken in 1903 and is one of only a few known images of Native Americans in the Three Lakes area. Larger Chippewa and Pottawatomi settlements were located to the north and south of Three Lakes. One early settler in the area was Hiram Benjamin "Hi" Polar. Polar traveled west with the Oneida Indians, who were forced to move by the US government, and he settled in Fort Howard, now Green Bay, in 1852. Shortly after arriving in Green Bay, he was employed by the government as a mail carrier; his route covered the area between Stevens Point and Ontonagon, Michigan. He was the first white man to travel over this route with mail. It was during this time that he met and married a Chippewa woman named Virgin, who is Virgin Lake's namesake. Polar and his wife settled on the shore of this lake and established a trading post. Town records show that, after Main Street was cleared, a road was cut to link with Military Road at Hi Polar's trading post on Virgin Lake. (Courtesy of the Three Lakes Historical Society.)

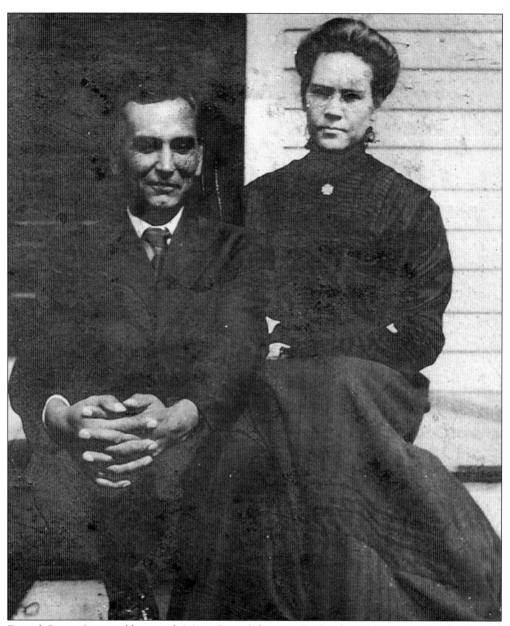

Daniel Gagen (pictured here with Mary Gagen), born in England in 1834, arrived in the United States in 1851 and worked in the copper mines of northern Michigan for a year. He relocated to Wisconsin and opened a trading post about two miles from Eagle River. In 1896, he moved his family to Three Lakes, which remained his place of residence until his death in 1908. Gagen became involved in the lumber business and took up farming near Pine Lake. He was the chairman of the Town of Three Lakes board for several terms. At the time of his death, he was the school clerk. He was a man of such prominence and influence that he was often referred to as "the King of the North." The town of Gagen, south of Three Lakes, was named after him. His son Henry Gagen also resided in Three Lakes and was active in logging, road building, timber cruising, and scaling. One of Henry's most notable achievements was the laying out and building of Highway 32. (Courtesy of the Three Lakes Historical Society.)

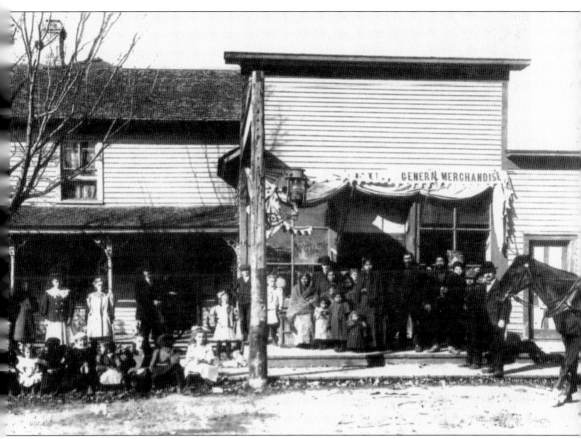

William Neu and his wife, Sarah, came to the area in the 1890s. Sarah described the area as "wild country." Neu did a flourishing business with the Indians on a strictly barter, no cash, basis. Traded items included things such as birch-bark canoes, baskets, beaded moccasins, wild rice, and ginseng root, which grew in abundance. This photograph shows Native Americans on the porch of Neu's store on Main Street in 1907. Neu was highly regarded among the Indians as an honest trader. He also published a paper in Crandon until 1892, at which time he moved operations to Three Lakes. The following year, he started his grocery business. (Courtesy of the Three Lakes Historical Society.)

The construction of Military Road was spawned by the belief that the British would come from Canada to help the Confederacy during the Civil War; however, the road was not completed through Wisconsin until 1869. The road then became important for logging, as Three Lakes was the shortest depot route to Military Road. Roads to lumber camps were referred to as "tote roads," and teams of horses hauling supplies to camps were referred to as "tote teams." (Courtesy of the Three Lakes Historical Society.)

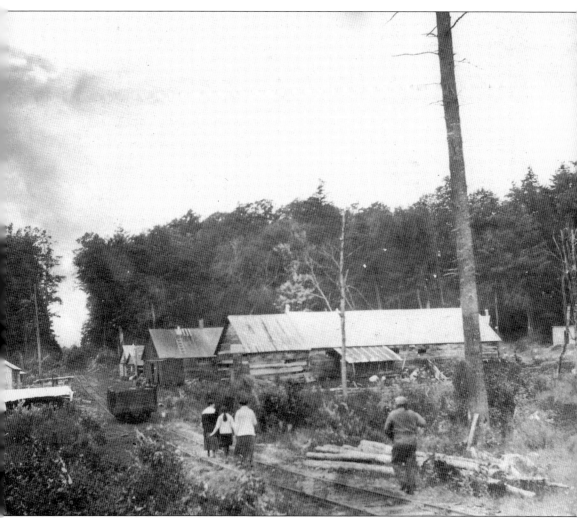

The arrival of the railroad in Three Lakes was spurred by the burgeoning logging industry, which in turn was fueled by the rapid growth of American cities due to the increase in immigration. Wisconsin timber was needed to meet the demand for construction of buildings in growing cities. As logging operations grew in scope, an efficient method of transporting the felled timber to the sawmills was essential. The Thunder Lake Narrow Gauge Railroad cut through the area, providing the vital link between the logging operations and area sawmills. The first mill to operate in Three Lakes was built by Hans Anderson of Antigo. (Courtesy of the Three Lakes Historical Society.)

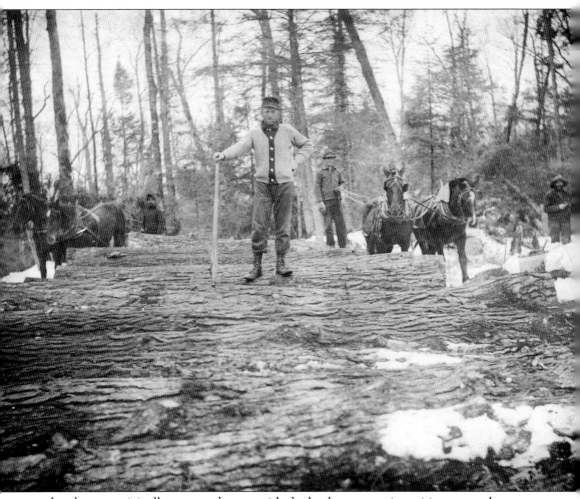

Lumbermen originally came to the area with the lumber companies as itinerant workers; some, such as Paul Dziewiatkowski (Javenkowski), were immigrants who arrived in the area with the goal of earning money to pay for the passage of their families to the United States. Javenkowski remained in the area as a lumberjack, and later became a homesteader and a farmer who farmed successfully for many years. Some men who owned farms in the area would be with their families until early winter and then return to camp. The women did the farm chores and took care of the children until spring. (Courtesy of the Three Lakes Historical Society.)

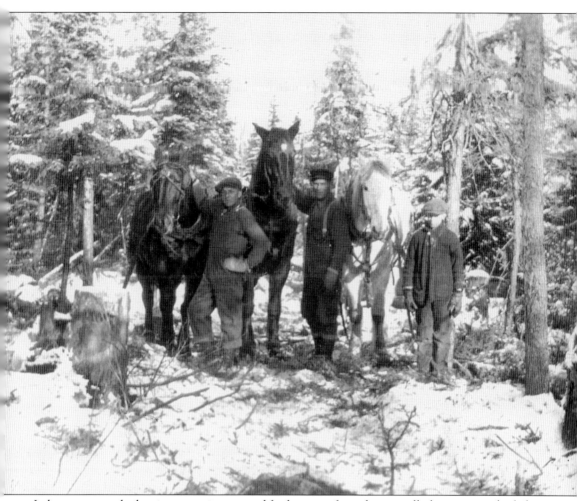

In later years, as the logging operations moved farther away from the sawmills, logs were stockpiled near the logging job and were later hauled out by a horse team like the one pictured here, or by improvised steam locomotives, referred to as "steam haulers." The advent of more mechanized logging operations eventually led to the end of the widespread use of horse teams. (Courtesy of the Kloes Collection, Demmer Memorial Library.)

Much of the early lumbering around Three Lakes involved cutting virgin timber and required the use of teams of draft horses to pull log sleds from the woods to local sawmills, and later, the Thunder Lake Narrow Gauge Railroad. These lumbermen were working near present-day Wheeler Island Road. (Courtesy of Lois Ralph.)

Accommodations for lumbermen were basic and often consisted of materials like small trees, tar paper, and whatever else was usable. Often, these buildings were left standing after the operations had ceased, but they were sometimes disassembled and taken to the next job. This image is of a bunkhouse at a logging operation near Planting Ground Lake. (Courtesy of Lois Ralph.)

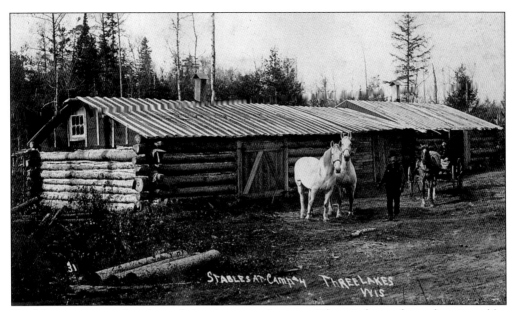

Draft horses were vital to the early logging operations near Three Lakes and were kept in stables in the lumber camps near the logging operations. Pictured here are the stables at Camp No. 4, near Three Lakes. There was a barn boss to tend the stables as well as men to cut the firewood and fill wood boxes. When they worked some distance from the camp, men would haul lunches to the crew. Wide-scale use of horses was later replaced upon the arrival of steam-powered equipment. (Courtesy of the Three Lakes Historical Society.)

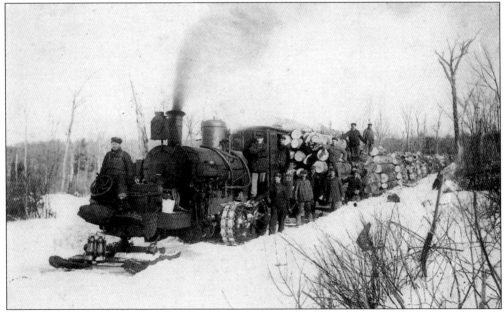

This improvised steam locomotive was used by the Thunder Lake Lumber Company to move cut timber out of the woods in the winter months to the sawmill. As logging operations progressed, the area became cutover, and lumber companies in search of a profit had to become more resourceful. One hauler replaced up to 16 teams of horses. Local teamsters were not happy. (Courtesy of the Three Lakes Historical Society.)

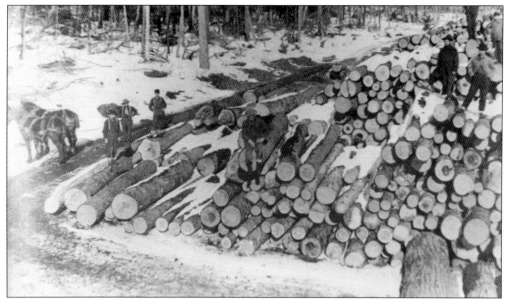

During the winter months, as lumber was cut, it was stockpiled in anticipation of moving it through the chain of lakes. Three Lakes Land and Lumber Company began logging in the early 1880s. In 1886, there were seven firms logging pine east of Three Lakes. To accommodate the increase in lumbering activity, the water levels in the chain of lakes was raised in order to more easily float the timber through the lakes to trains, which would transport the timber to sawmills. (Courtesy of the Kloes Collection, Demmer Memorial Library.)

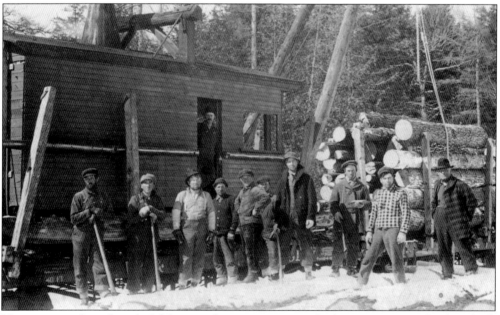

Here, men rest from their day's labors on this steam jammer, also known as a steam loader, which sits next to the Thunder Lake Narrow Gauge Railroad. Steam jammers were used to load and unload large cut timber onto railroad cars and log sleds and proved to be invaluable pieces of equipment. Logging companies, ever intent on turning as much profit as possible, made good use of innovations in machinery. (Courtesy of the Kloes Collection, Demmer Memorial Library.)

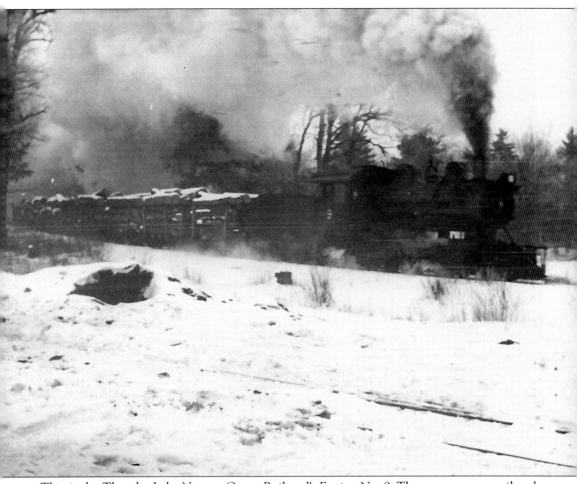

This is the Thunder Lake Narrow Gauge Railroad's Engine No. 9. The narrow-gauge railroad played a vital role in transporting supplies to the lumber camps and hauling cut timber to the lumber mills. Engine No. 9 was a legendary workhorse for the Thunder Lake Lumber Company. Supplying the lumber camps was no small task. Each camp employed about 125 men. (Courtesy of the Kloes Collection, Demmer Memorial Library.)

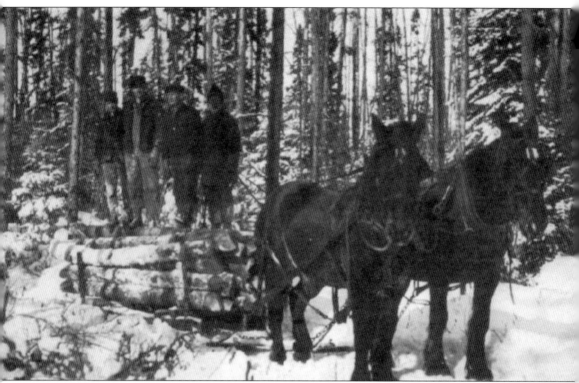

Despite innovations made in the machinery used to make logging operations more efficient and cost-effective, draft animals such as horses were still an important part of logging operations, as they could haul cut timber out of more difficult terrain. These horses are hauling logs on a "bunk" log sled. Logging companies would often encourage competitions between camps to see which could have their horse teams haul the largest load of logs. In Wisconsin, as in other states with large logging operations, it became a source of pride to be able to boast the largest load of logs on a sleigh. While the competition raged among the different Wisconsin logging companies to claim the largest load of logs, in 1893, there were 50 logs perfectly decked on a sleigh at a camp near Ewen, Michigan, about 70 miles north of Three Lakes. Scaled at 35,000 linear feet, the load was disassembled and exhibited in Chicago at the 1893 World's Fair. (Courtesy of the Kloes Collection, Demmer Memorial Library.)

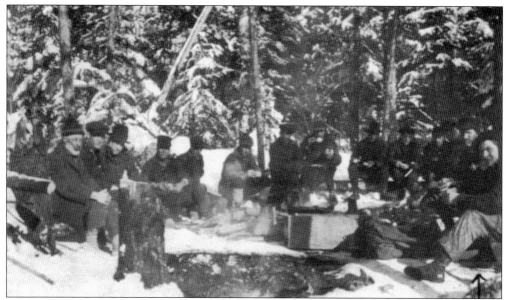

Life in most lumber camps would begin early in the morning with a large breakfast, which was followed by a walk to the work location. At lunch, the men would walk back to the camp for a large lunch and then head back to the job. The evening meal was usually quite ample. The average lumberman consumed 5,000 to 8,000 calories per day. These men are eating food brought to the work site from the camp. (Courtesy of the Kloes Collection, Demmer Memorial Library.)

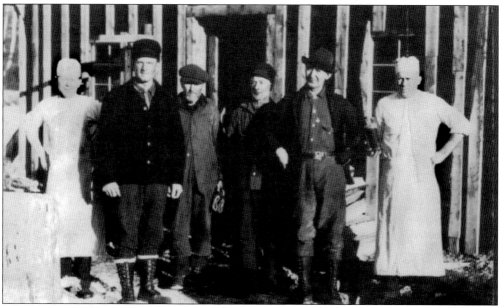

Each camp had one cook and a helper called a cookie; the cookie set and cleared the tables, and washed the dishes. A good cook really satisfied the lumberjacks. The men would quit if the cook was bad, which was called "going down the hay road." The lumber companies furnished good food, and it was plentiful. There were two good cooks who lived in Three Lakes, William Bennett and Henry Levandoski. (Courtesy of the Kloes Collection, Demmer Memorial Library.)

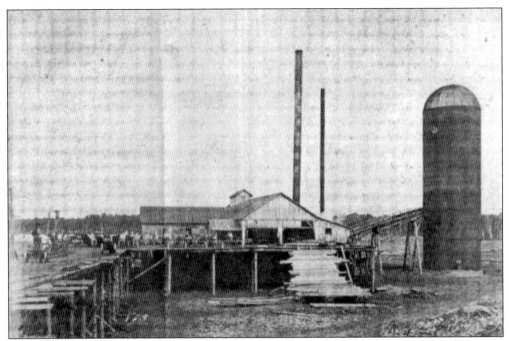

Built one mile north of town on the Korzelius property after the first mill town burned, the Woodruff-McGuire Lumber Company constructed Buckwheat. It was an active mill town and was no small operation. Every day, it converted 85,000 board feet of lumber in two 12-hour shifts. Buckwheat was a community unto itself and received its name because local businessman James Donnely attempted to grow a crop of buckwheat in that area, but it failed as it was too wet. By 1900, Buckwheat was a ghost town. (Courtesy of the Three Lakes Historical Society.)

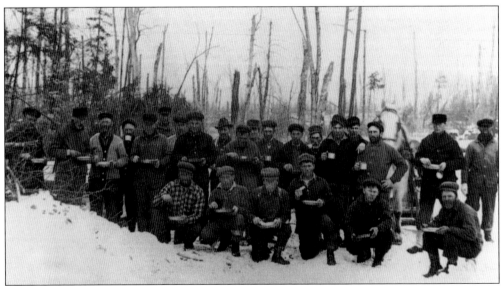

Lumber companies continued to clear large tracts of timber from the land, and scenes such as this with a barren landscape in the background were common. As the companies exploited the forest, the end of wide-scale logging was drawing to a close. (Courtesy of the Kloes Collection, Demmer Memorial Library.)

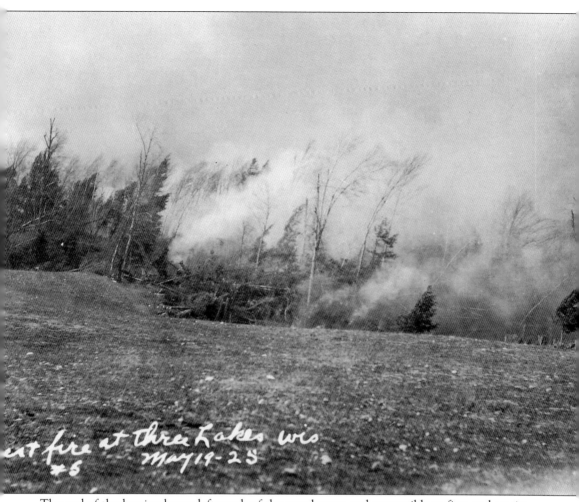

cut fire at three Lakes wis
#5 May 19-25

The end of the logging boom left much of the area barren and susceptible to fires and erosion. Scenes such as this were common throughout much of Wisconsin's Northwoods. (Courtesy of the Kloes Collection, Demmer Memorial Library.)

Three Lakes Milestones

1859–1890

1859 John Curran opens a trading post at Pelican Rapids (Rhinelander), and the firm of Hurley and Burns begins logging along the shores of the Eagle River and Three Lakes chain of lakes.

1860 Hi Polar establishes a trading post on the Lake Superior Trail at Virgin Lake. Dan Gagen establishes his trading post on the shore of Pine Lake (Hiles) on the proposed Military Road.

1872 About this time, US Post Office Department contracts were issued to carry mail up the Military Road at regular intervals.

1877 The Polarski family homesteads near Mud Lake (now Crystal Lake), which is close to present-day Three Lakes.

1879 The Township of Gagen, including the present town of Three Lakes, is established. The Cohn and Carran Lumber Company builds a logging camp at Otter Rapids, south of Eagle River.

1880 Lumbering begins in the Three Lakes, Monico, and Gagen area. The Three Lakes Land and Lumber Company starts logging in Three Lakes.

1881 Three Lakes is founded by the Milwaukee Lake Shore & Western Railroad, later known as the Chicago & Northwestern Railroad.

1882 Julius Johnson arrives in Three Lakes to help build the railroad. Joe Gorski arrives in Three Lakes and works to provide supplies to the lumber camps. The first steam locomotives arrive in Three Lakes and Rhinelander, and the area is opened up to large-scale logging.

1884 The Catholic Mission of St. Theresa is established in Three Lakes.

1887 Oneida County is formed, and Three Lakes is officially a part of the county.

1890 Homesteading is opened up for land around the Three Lakes chain of lakes. The Julius Johnson family purchases land in Three Lakes. The building is now a part of the Three Lakes Historical Museum. The first Catholic church is built in Three Lakes.

Two

MAIN STREET

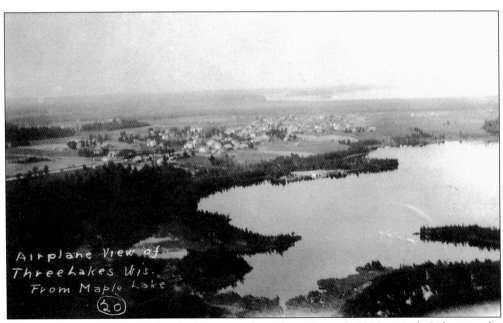

This aerial view of Three Lakes looking west dates from the early 1920s. Maple Lake is in the foreground and the 1894 schoolhouse is in the background. (Courtesy of Dave and Jan Hintz.)

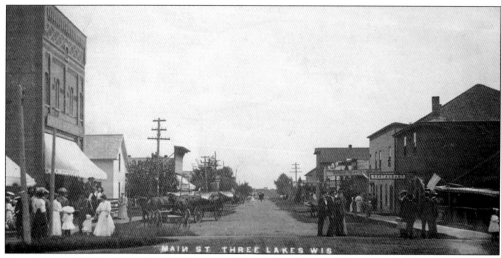

This image of Main Street in 1903 is one of the earliest-known photographs showing what the town looked like in the early years of its existence. The large brick building on the left is the F.S. Campbell general merchandise store; if still standing today, it would be located on the north corner of the US 45 and Highway A intersection. The Campbell store was later dynamited and completely destroyed. F.S. Campbell became a prominent potato farmer. (Courtesy of the Three Lakes Historical Society.)

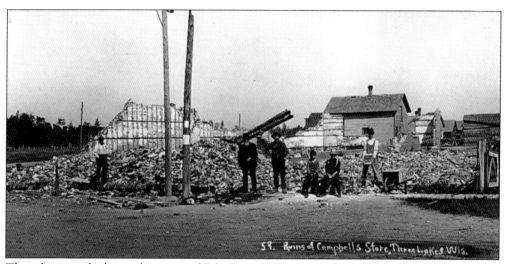

This photograph shows the ruins of F.S. Campbell's store. Three Lakes did not have a fire department at the time, and buckets could not put out the fire. Campbell had no insurance and could not afford to rebuild, so he began developing his potato farm outside town. While the exact reasons for the destruction of his store are not known, many suspect it was linked to the political struggles of the community tied to the sale of alcohol. Campbell was known to have supported efforts to close saloons in the town and is said to have furnished officers to secure evidence regarding businesses that were selling bootleg liquor in an effort to have it stopped. (Courtesy of the Three Lakes Historical Society.)

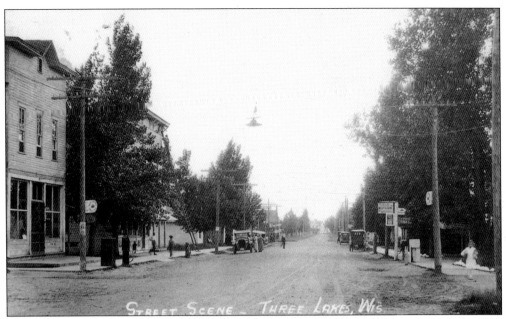

This view of Main Street around 1920 facing west features the Dobbs general merchandise store and the Olkowski Building on the left. Main Street was still dirt, and the sidewalks were constructed of planks. The poles running along the streets appear to be for telephone service. In 1922, William and Clara Brandner ran the local telephone exchange, where the Oneida Village parking lot is now located. They offered a 24-hour service on crank-type telephones. In 1927, Charlie Dobbs took over the phone service following William Brandner's death. (Courtesy of the Three Lakes Historical Society.)

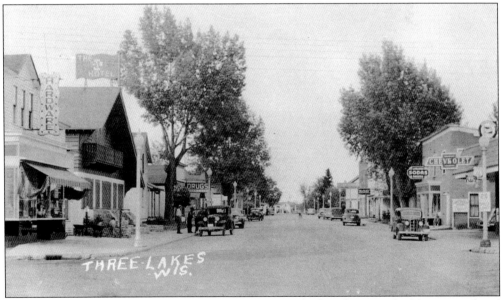

This mid-1930s image of Main Street looking east reveals that the street had been paved and electric streetlights had been installed (around 1932). Many of the buildings had been repaired or rebuilt after the 1924 tornado destroyed a significant portion of the town. (Courtesy of the Three Lakes Historical Society.)

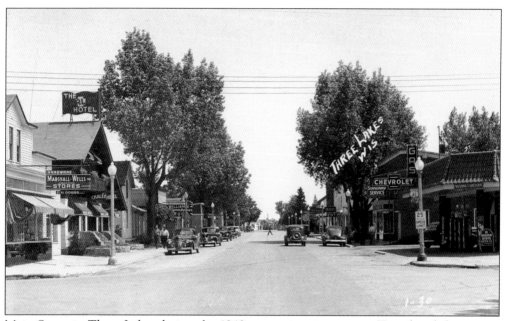

Main Street in Three Lakes during the 1940s was quite picturesque. Trees lined the streets, complemented by aesthetically pleasing streetlights, a well-maintained roadway, and crisp storefronts. The old Olkowski Building can be seen in the upper right; Three Lakes Hardware appears in the lower left, next to the Chalet Hotel, which no longer stands. (Courtesy of the Three Lakes Historical Society.)

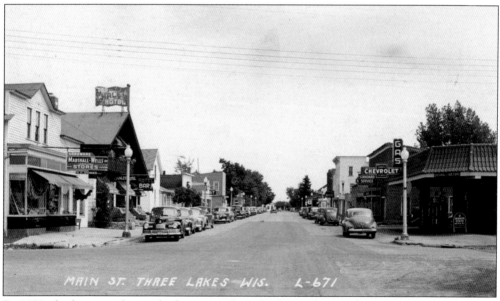

By 1950, the business district had not significantly changed since the 1924 tornado destroyed portions of it. In 1956, Stanley "Buster" Javenkowski became Three Lakes' first chief of police. Prior to that, the town only had night watchmen, or constables. Javenkowski was paid for 40 hours per week but often worked 100 hours, volunteering extra time on the job because it was expected. (Courtesy of the Three Lakes Historical Society.)

EAGLE RIVER REVIEW

VOLUME 38—No. 17 EAGLE RIVER, VILAS COUNTY, WISCONSIN, THURSDAY, September 25, 1924 PRICE $2.00 A YEAR

Tornado Wrecked Three Lakes Sunday

On September 21, 1924, Three Lakes fell victim to a powerful and destructive tornado. According to accounts of the day, the weather was humid and oppressive. The tornado caused in excess of $200,000 in damages and destroyed a significant part of the town. (Courtesy of the Three Lakes Historical Society.)

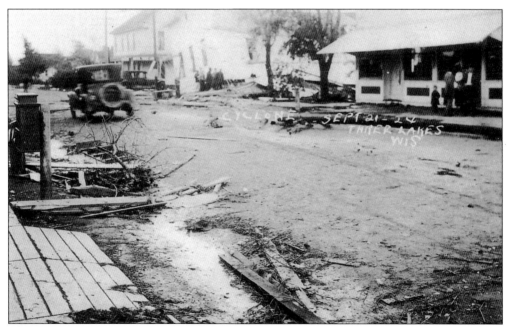

This view of Main Street facing east following the tornado shows that much of the business district had been destroyed in the storm. The second floor of the Dobbs general merchandise store was blown off the building and partially rested on the street and on the walls of the first floor of the store. Trees were ripped out and strewn throughout the town. (Courtesy of the Three Lakes Historical Society.)

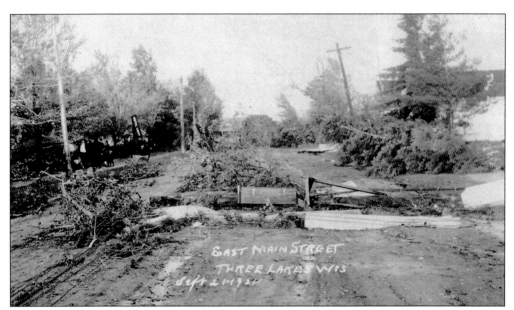

This view of Main Street reveals the scope of the destruction caused by the tornado. Most of the trees were uprooted, but not broken, and were simply lying straight on the ground with their roots exposed. St. Theresa Catholic Church and the Union Congregational Church (UCC) were both badly damaged. Their steeples were blown off, and most of the UCC was destroyed and needed to be completely rebuilt. The railroad depot and freight house were terribly damaged as well. (Courtesy of the Three Lakes Historical Society.)

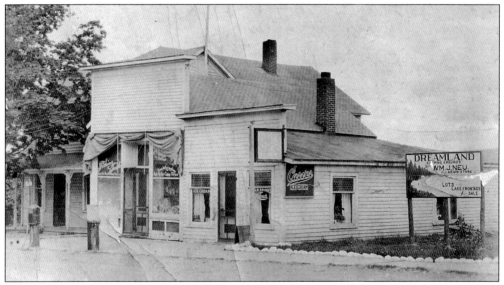

William Neu was a prominent businessman who moved to Three Lakes in 1892 from Crandon, where he served as a clerk of the circuit court and deputy sheriff and was the first game warden of Florence, Vilas, Oneida, and Forest Counties. He purchased a building from William Cashman, who was one of the earliest entrepreneurs in the community. Neu operated a successful grocery store, and as his business grew, he added an ice cream parlor, dabbled in real estate, and built Dreamland Camping Cabins on Maple Lake. He installed the town's first one-gallon gas pump in front of his store. (Courtesy of the Three Lakes Historical Society.)

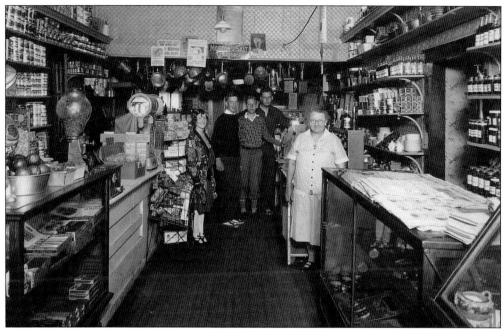

William Neu's grocery store was only one of his many business and community endeavors. In addition to his store, Neu also ran a newspaper and served the community as town clerk, treasurer, and justice of the peace. He was also postmaster for 12 years. (Courtesy of the Three Lakes Historical Society.)

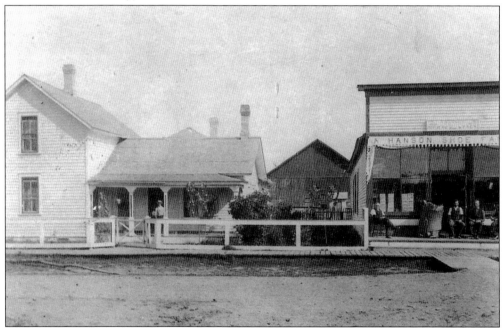

This is an image of the Andrew Hanson Shoe Factory, once located on Main Street in Three Lakes next to the present-day Kelley Law Office. Hanson was highly regarded for his craft, and according to a Mr. Black of Shawano, Wisconsin, "any lumberjack worth his salt on the drive got his caulked boots at Three Lakes, Wisconsin." (Courtesy of the Three Lakes Historical Society.)

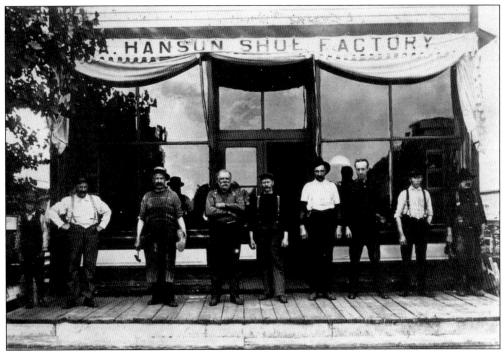

Andrew Hanson employed 15 men in his shoe factory to produce custom-made footwear. A typical pair of Hanson boots had leather tops with rubber bottoms sewed on, and when the bottoms wore out, Hanson would sew on new ones. (Courtesy of the Three Lakes Historical Society.)

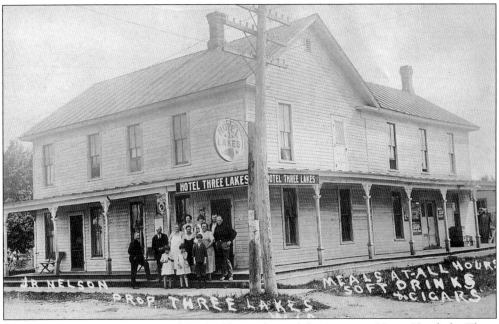

Before Lowey's Restaurant occupied this building, it housed the American House Hotel, the Three Lakes Hotel, and finally, Lowey's Hotel and Restaurant. According to records, over a 10-year period the hotel had 7,426 guests. It was torn down, and a Best Western was erected in 1970. Today, the Oneida Village occupies this location. (Courtesy of the Three Lakes Historical Society.)

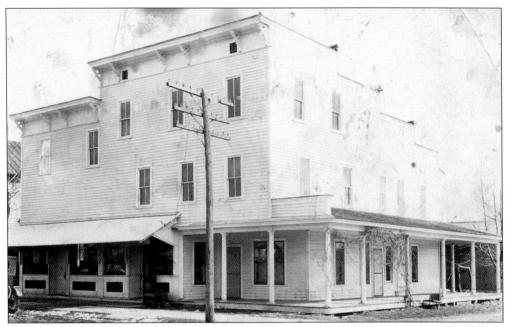

In 1890, John Olkowski moved to the edge of town and farmed for about five years. He then purchased a saloon, which today is occupied by the American Legion. He added on to the original building and entered the grocery and meat market business. (Courtesy of the Three Lakes Historical Society.)

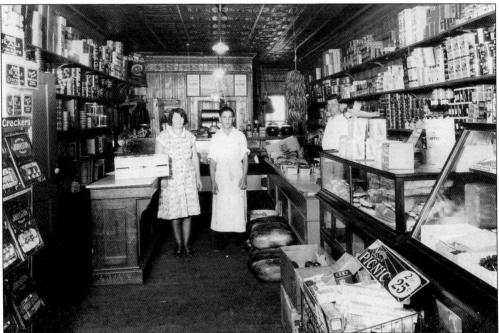

The interior of Olkowski's City Market is shown here. Pictured in the center of the store are Gladys Olkowski Antusik and Leland Gehrke. John C. Olkowski is standing behind the counter. Olkowski's City Market featured a full line of groceries as well as meats and produce. (Courtesy of the Three Lakes Historical Society.)

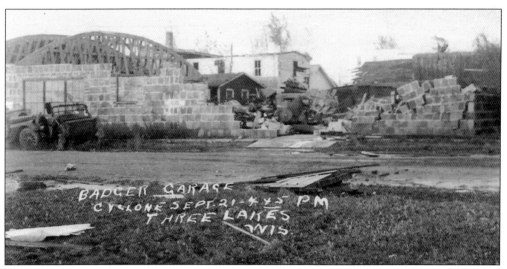

Ed Epler got his start in the garage business by repairing boat engines, mostly inboards, for Ace Rhinehart. Epler and Ray Barker built the Badger Garage on Maple Lake flats and moved downtown after World War I. Epler was highly regarded as a skilled mechanic and civic-minded individual. The garage business was essential at a time when automobiles required substantially more maintenance as tourists drove between Three Lakes and their homes. Pictured above is the Badger Garage after it was damaged by the 1924 tornado. (Both, courtesy of the Three Lakes Historical Society.)

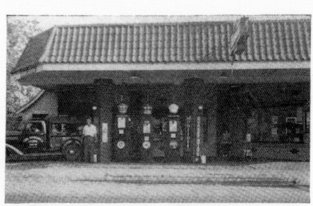

Badger Garage
Chevrolet Service

GAS - OIL

OUTBOARD MOTOR SERVICE

ONE-STOP SERVICE

Phone 171; Night 441 Three Lakes, Wis.

 E. H. EPLER

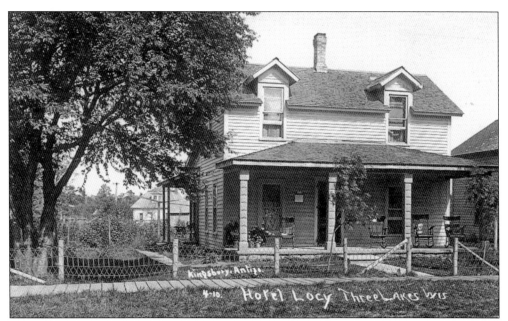

The Hotel Locy harkens back to an era when life was considerably more relaxed. The high rockers on a covered porch symbolize the character of a community that many visitors sought. Locy also operated a transport from the depot to resorts on the chain of lakes. In 1940, the Hotel Locy became the Sunnyside Hotel. The building still stands on Superior Street today. (Courtesy of the Three Lakes Historical Society.)

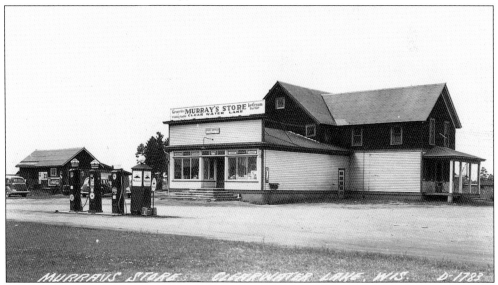

Murray's Store in Clearwater Lake was built in 1912 by Mr. and Mrs. Henry Kranz. It was later sold, and later run by Caroline and Walter Murray. They provided residents and visitors with groceries, an ice cream parlor, and gasoline. In later years, the store also housed the Clearwater Lake Post Office after Walt Murray became postmaster and held that position until his death. When the post office was located in the store, it was a neighborhood meeting place. The structure stands today and has been used as a restaurant in recent decades. (Courtesy of the Three Lakes Historical Society.)

Murray's Store

CLEARWATER LAKE

General Merchandise

ICE CREAM PARLOR

"Service With A Smile"

The State Bank of Three Lakes was established on November 6, 1912, with a capital of $10,000, which increased to $25,000 on July 25, 1918. The bank was organized by Clark Kueny and his business associates and continued to do business until April 2, 1923, when it was closed by order of the state banking commissioner, who found that it had accumulated too much "frozen paper," or frozen assets. It was reorganized as People's State Bank and was chartered in 1923. F.H. Dobbs, who also owned a general merchandise and grocery business, had substantial land holdings, and owned a local hardware store and resort cottages in the area, was named president. The bank stood on the location of the current BMO Harris Bank on Superior Street. (Both, courtesy of the Three Lakes Historical Society.)

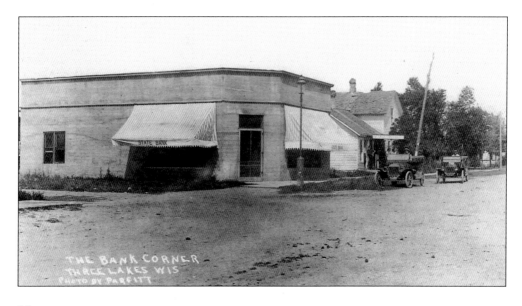

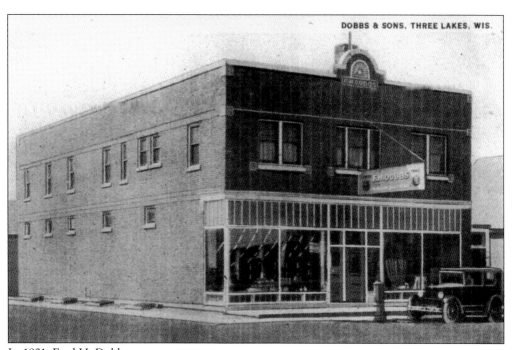

DOBBS & SONS, THREE LAKES, WIS.

In 1921, Fred H. Dobbs moved to Three Lakes with his wife and children, and they purchased a two-story wooden grocery and general merchandise store on the corner of West School and Superior Streets. The wooden structure was destroyed in 1924 by a tornado that devastated much of Three Lakes. The Dobbses rebuilt their business with a more substantial brick structure, pictured above, and ran it until their retirement. Fred Dobbs was also president and manager of People's State Bank of Three Lakes, on the Three Lakes School Board, and was active in the Rotary Club. (Both, courtesy of the Three Lakes Historical Society.)

37

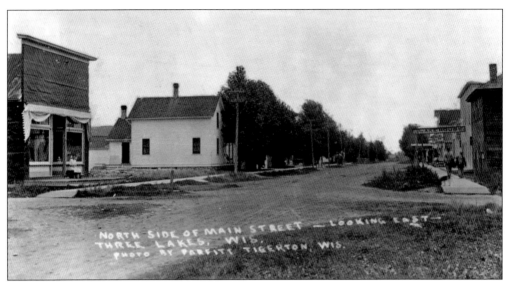

Frank McNinch was one of the earliest settlers in Three Lakes, having arrived several years after the railroad line was established. He operated a grocery store near the depot, and his business was the first place many of the town's visitors would frequent upon their arrival. McNinch ran a thriving business until he sold his store to F.H. Dobbs, who turned it into a hardware store. The present Three Lakes Hardware is located on the site of the former McNinch store, pictured here at far left. (Courtesy of the Three Lakes Historical Society.)

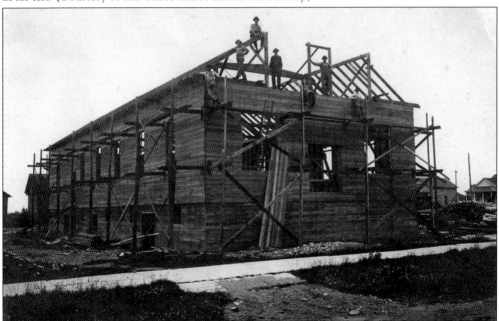

The Three Lakes Opera House, pictured here under construction, also doubled as the town hall. It was built west of the railroad tracks across from the railroad depot. This hall was the scene of many stormy sessions, which were often settled by a decision of the house. The building was destroyed by the tornado that razed much of the town in 1924. As a child, Gene Step ran playbills through town advertising the evening performance and sat by the back door to watch the show. (Courtesy of the Three Lakes Historical Society.)

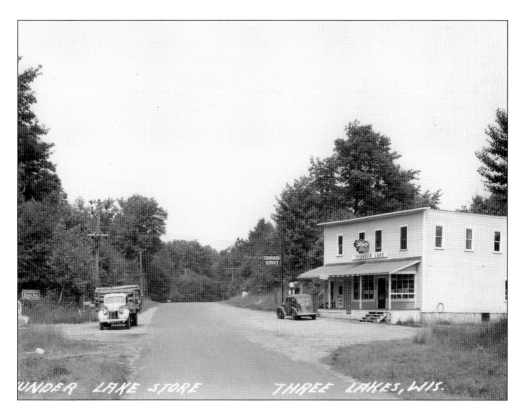

THUNDER LAKE STORE THREE LAKES, WIS.

The Thunder Lake Store was located near where Highway 32 approaches Whitefish Lake. It was originally operated by the Thunder Lake Lumber Company as a company store, supplying the many lumber camps in the area. After the lumbering boom era drew to a close, the store became known as Bell's Market. (Both, courtesy of the Three Lakes Historical Society.)

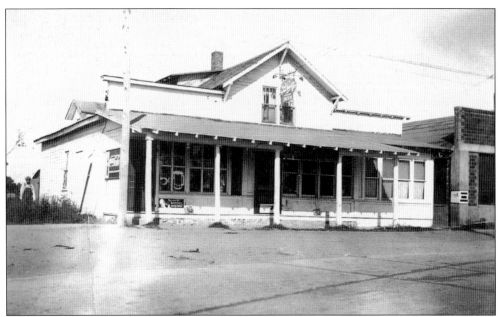

Mary Berg opened a grocery store and meat market in Three Lakes in 1920 after she sold Oak Grove Resort in Clearwater Lake. She died in 1921, and her family sold the store to Otto Tryczak, who changed it to a garage and later sold it to Merle Patnode Sr. The building later burned. (Courtesy of the Three Lakes Historical Society.)

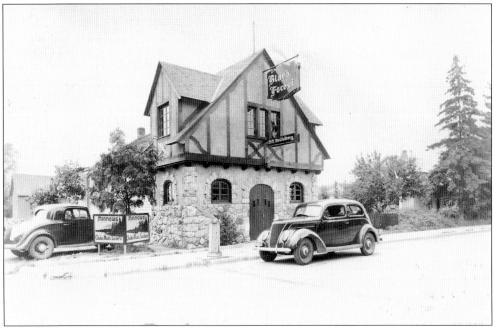

The Black Forest is among the notable buildings in Three Lakes designed by Cy Williams. Williams designed the Black Forest so that it appeared like a building out of the beer gardens of Germany's Black Forest. Orville Basch hired Williams in 1934 and commissioned him to construct his new Three Lakes tavern and specifically requested that it resemble such structures. (Courtesy of the Three Lakes Historical Society.)

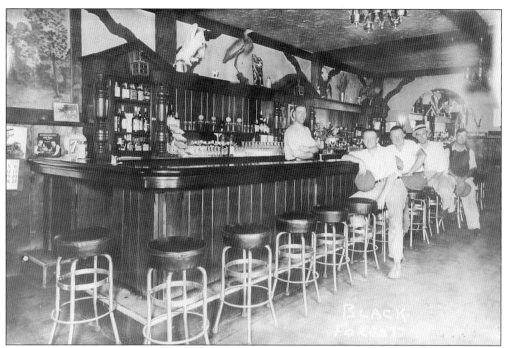

Comparing these pictures of the Black Forest taken shortly after it opened its doors in 1934 with how the barroom looks today, it is apparent that not much has changed since then. The building has been added onto twice since it opened, and at one time the tavern also featured a bowling alley. (Both, courtesy of the Three Lakes Historical Society.)

Modern, Up-to-Date Cocktail Lounge

Cool - Inviting - Rustic

VISIT THE UNUSUAL—

The Black Forest

Bill Liston, Prop. THREE LAKES

Three Lakes Milestones

1891–1900

1891 John Stypcznski (Step) moves to Three Lakes and opens a blacksmith shop with his son Alex.

1892 Badger Paper Company establishes a sawmill and tamarack logging operation near Mud Lake. The American House Hotel becomes the Three Lakes Hotel; the Lake House Hotel opens. William Neu buys Cashman's general store in Three Lakes and moves his newspaper from Crandon to Three Lakes.

1893 Charles French builds Butternut Lake Resort. Brown & Robbins begins construction on a narrow-gauge railroad from Rhinelander to the north; the Chicago & Northwestern Railroad buy out the Milwaukee Lake Shore & Western Railroad. Otto Tryczak establishes his homestead on Big Stone Lake; a Free Methodist Society is organized in Three Lakes and begins meetings.

1894 Three Lakes builds a large wooden schoolhouse on the site of the present Demmer Library.

1897 Gustave Adolph Kloes begins homesteading on Big Lake and starts Big Lake Resort.

1898 Charles French builds Pine Island Resort on what is now Denby Island. The Town of Sugar Camp is established.

1899 The Rod and Gun Club on Laurel Lake is organized. A low dam is built on the Eagle River at the site of the present Burnt Rollways Dam to raise the water on the Three Lakes Chain. Lumbering in the Three Lakes area is at its peak. The last major river log drive occurs at Rhinelander and half of its mills are shut down.

1900 Five one-room schoolhouses are operating in the Three Lakes Area. The Woodruff-McGuire Company builds a sawmill and a town at Buckwheat near Townline Lake. The Free Methodist Society builds a church on the present site of the Union Congregational Church. A forest fire nearly destroys Three Lakes. Lake property is selling for $1.25 per acre.

Three

HEART OF THE COMMUNITY

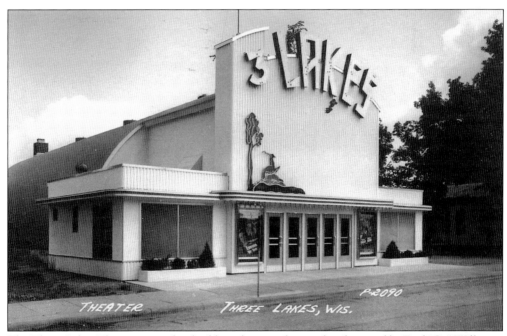

The Three Lakes Theater is another building that was designed and erected by Fred "Cy" Williams. Williams won an award for the design of the theater, which has been a part of the Three Lakes landscape since its construction in 1946. It was recently renovated and is currently operated as the Three Lakes Center for the Arts. (Courtesy of the Three Lakes Historical Society.)

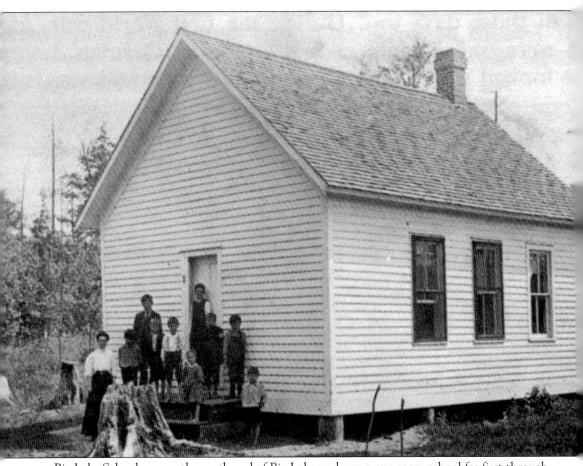

Big Lake School was on the south end of Big Lake and was a one-room school for first through eighth grades. There were seldom enough students to have one in each grade. Most left school and went to work before eighth grade. In the early 1900s, when these one-room schools opened, they were only open during the summer months. According to Bill Kloes, "in later years, the schedule was changed, and kids were in school in the winter and off in the summer. Getting to school through the snow was still a problem. I made a pair of skis for one teacher so she could get to school a little easier. My brother Gust and I kept the trail open for her all winter." The building had many uses besides being a school. Dances, elections, and community meetings were also held there. Today, many of these buildings that housed one-room schools are residences. (Courtesy of the Three Lakes Historical Society.)

This is a very early photograph of the Virgin Lake School, located on Highway 32. At one time, there were eight one-room schoolhouses that educated students through the eighth grade. Big Lake, Pomes, and Virgin Lake were open during the summer months but were closed during the winter because the snow was too deep and they were too difficult to heat. (Courtesy of the Three Lakes Historical Society.)

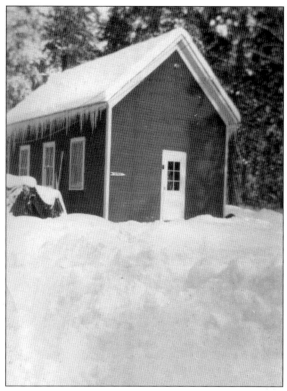

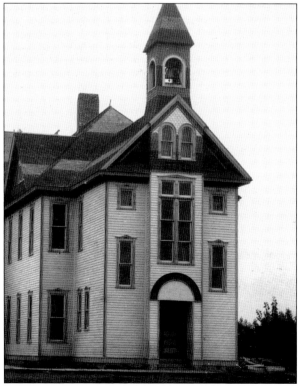

The construction of a larger school building in 1894 marked the beginning of the end of the one-room schoolhouses. The structure, pictured here, stood on the site of the present Demmer Library and was constructed for a cost of $1,000. As the population grew and more school-aged children were in the community, the building was added onto in order to accommodate the demand for additional classrooms. (Courtesy of the Three Lakes Historical Society.)

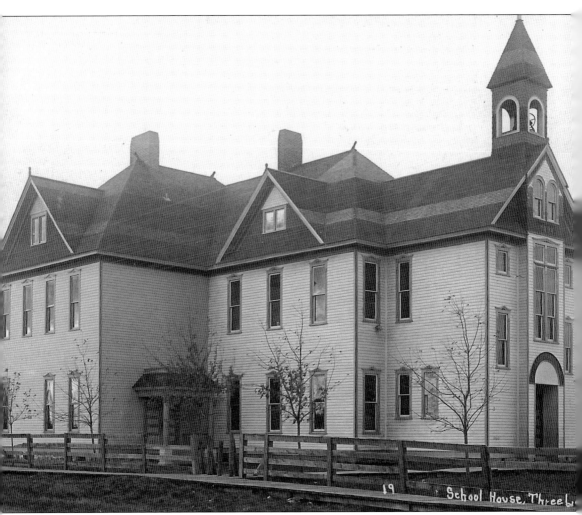

The Three Lakes School, pictured in 1920, had been expanded to include a kindergarten and to provide additional space for children who were now being brought into town from the one-room schoolhouses to receive a more comprehensive education. Three Lakes students who wished to pursue their education beyond their junior year attended school in Rhinelander and boarded with families there. (Courtesy of the Three Lakes Historical Society.)

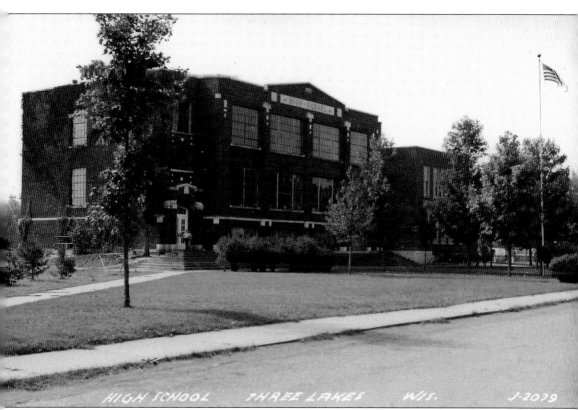

The community of Three Lakes constructed a brick school building in 1923 to accommodate the continued growth of the school system. The original building, pictured here, replaced the one constructed in 1894, and was later renovated and expanded. The principal's office in 1923 was at the very top of the east stairs and opened on the west to a stage, which was at the east end of the auditorium. A library and an art room were on the north side of the third floor. Lunch was served in the gym between classes. The construction of the new gym in 1939, plus three classrooms leading off the west side of the west stairway, was a Works Progress Administration (WPA) project during the Roosevelt administration. The rooms added were a music room, a science lab, and a shop room. In the late 1940s, an effort was made in Wisconsin to reduce the 4,000 plus school districts, and Three Lakes was consolidated with the neighboring communities of Sugar Camp, Monico, and Piehl, all of which had no high schools. (Courtesy of the Three Lakes Historical Society.)

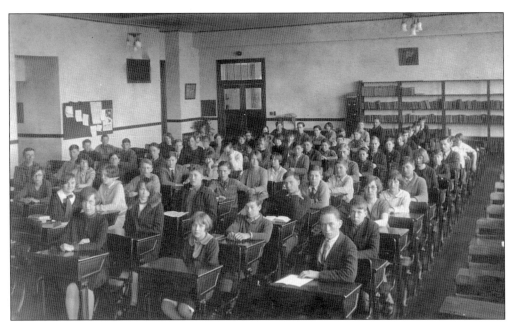

The Three Lakes High School's seventh and eighth grade assembly room, pictured around 1928, was on the second floor of the brick structure that was constructed in 1922–1923. The school system continued to grow, and the curriculum was expanded. Students could now remain in Three Lakes for kindergarten through 12th grade. (Courtesy of the Three Lakes Historical Society.)

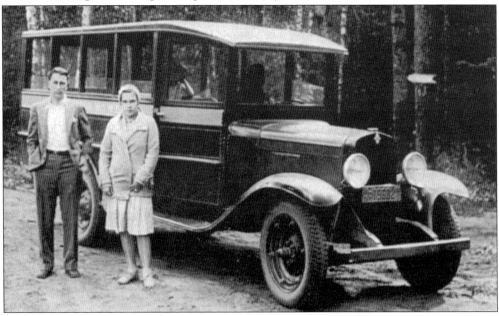

Early school busses were converted trucks. In 1926, Bill Paremski drove a Model T Ford. In 1930, he bought his first regulation school bus, followed by a larger bus, and drove for 40 years. This photograph is of Alan "Dusty" Rhoades and his sister Virginia in front of the school bus driven by Clark Stoneking. Dusty would serve with distinction in World War II and return to the community to work in the school system as a much-respected custodian until his retirement. (Courtesy of the Three Lakes Historical Society.)

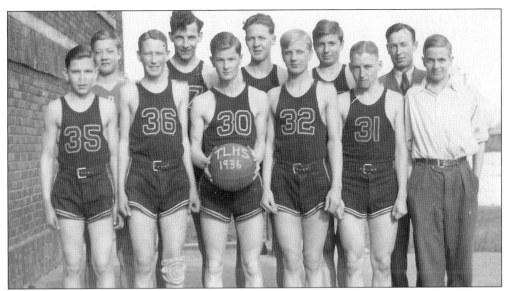

In towns like Three Lakes, high school sports were an important part of community life. High school athletes, both male and female, who wished to play on a basketball team had to raise money to put in a wooden gymnasium floor, and their parents had to purchase extra basketballs because the school only provided them with one. The teams traveled to their games by train until buses became common. (Courtesy of the Three Lakes Historical Society.)

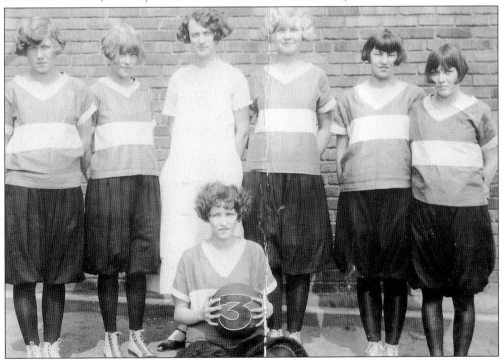

Before Title IX mandated equal opportunity for all students regardless of gender, communities such as Three Lakes sponsored girls' basketball teams. This picture is of the 1926 Three Lakes High School girls' team, all sporting the most fashionable uniforms available, complete with bobbed haircuts. (Courtesy of the Three Lakes Historical Society.)

Lt. Brewster Is In Three Lakes

THREE LAKES, June 13 (By News Correspondent)—Lieut. Norman Brewster, a prisoner of the Germans for two years, has arrived here to visit his wife and daughter and other relatives.—Sgt. and Mrs. John Miller have arrived here from Milwaukee for a vacation. Sgt. Miller is a liberated prisoner of the Germans.

The community of Three Lakes is home to scores of men and women who have served in places of conflict around the world. Like most small communities, Three Lakes saw the largest number of its young men and women volunteer or be drafted into service during World War II. Norman Brewster was among the residents who served overseas during World War II. Brewster was serving as a bombardier on a Flying Fortress based in England, which was shot down over German-occupied France in August 1943. Brewster was captured and imprisoned by the Germans until May 1945. (Courtesy of the Three Lakes Historical Society.)

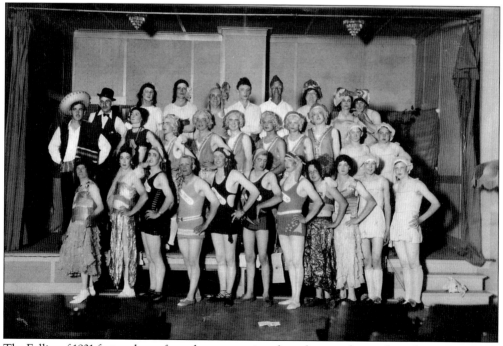

The Follies of 1931 featured men from the community who volunteered to perform three consecutive evenings to raise money for the local churches. Each evening the show was performed, the men played to a packed house. (Courtesy of the Three Lakes Historical Society.)

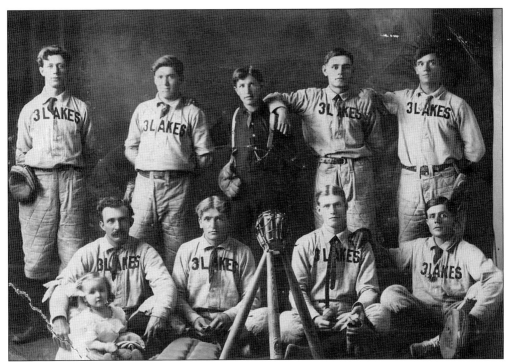

Communities such as Three Lakes often boasted their own men's baseball team. This image of the 1913 team features John Weiss, F. Gehrke, Frank Johnson, Art Lamor, Clark Kuney, John Crawford, Walt Lamor, Hugh Campbell, and Joe Bonkowski. (Courtesy of the Three Lakes Historical Society.)

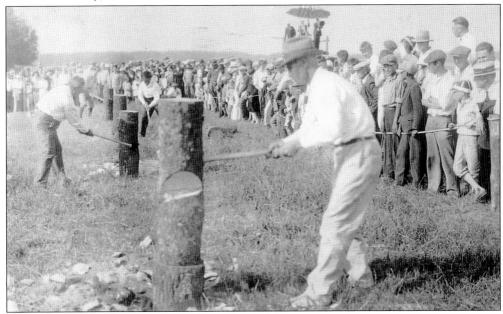

The Three Lakes Summer Carnival was held at the Bridge Tavern, which was located near the Big Stone Golf Course. The carnival featured wood-chopping competitions, field events, and logrolling. (Courtesy of the Three Lakes Historical Society.)

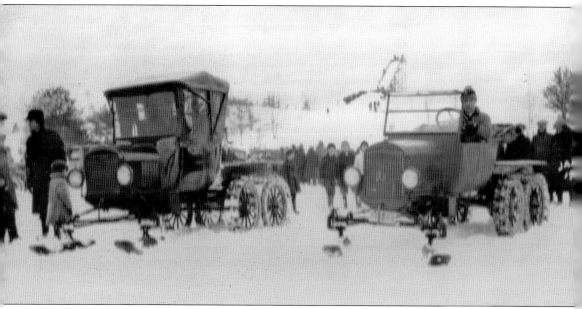

In 1965, Eagle River was planning its second annual snowmobile derby. According to an issue of the *Three Lakes News* from that year, some claimed that the idea for such a derby originated there, while others claimed that Three Lakes held the honor: "and perhaps rightly so, for this town had its own form of a snowmobile derby, on a small scale in 1926. Bill Neu, of Three Lakes won a .22 caliber rifle as first prize in the competition. Neu was one of two contestants in the derby, which was part of the first winter sports carnival in the area. More than 200 persons were on hand for the event held on Range Line Lake, a mile north of Three lakes. Besides Neu, the other contestant in the race was a gentleman by the name of Hanson." Pictured here are those early snowmobiles in 1926. As Neu recalled, "They were a far cry from the up to date and very popular snow sleds of today, but they were the originals 39 years ago." (Courtesy of Dave and Jan Hintz.)

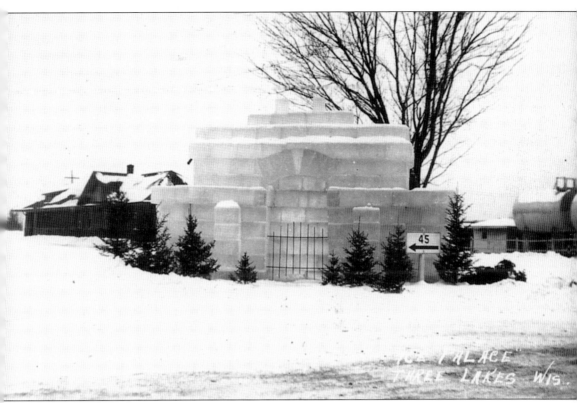

One way the wintry beauty of Three Lakes was improved upon was the construction of an ice palace in the 1930s. The palace was lighted by several large electric bulbs with colored paper between the ice and each bulb. The practice of building an ice palace was not continued long beyond the 1930s. (Courtesy of the Three Lakes Historical Society.)

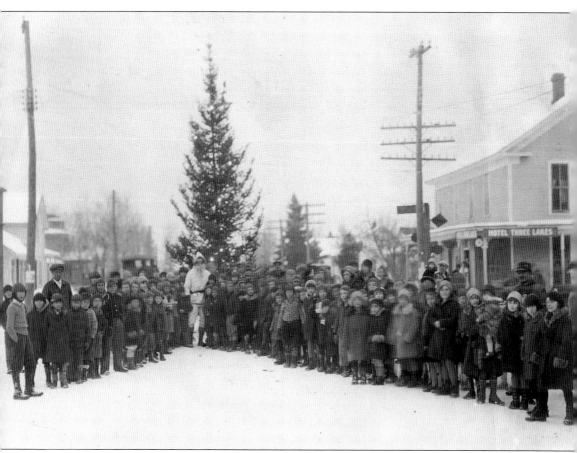

Herman Puls, an early hotel keeper in Three Lakes, is credited with founding an annual Christmas party for the children of the area. A large Christmas tree was erected in the center of Main Street at the "bank" corner and was decorated and lighted for Santa's appearance the day before Christmas. Free candy and fruit, provided by Herman Puls, were distributed. (Courtesy of the Three Lakes Historical Society.)

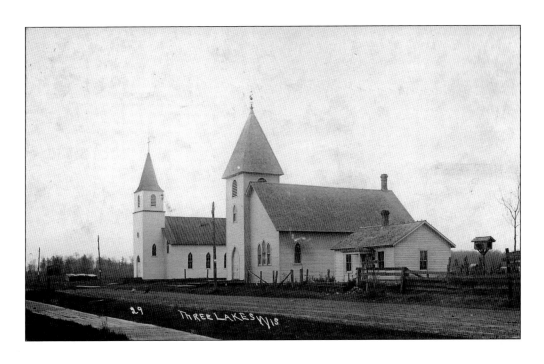

The congregations of Union Congregational Church and St. Theresa Catholic Church have been located near one another for nearly as long as they have been in existence. However, before the Congregational church was located across the street, the building was used by the Free Methodist Society. The photograph above, taken prior to the 1924 tornado, shows the two buildings. Both churches were badly damaged by the storm. (Both, courtesy of the Three Lakes Historical Society.)

St. Theressa Catholic Church

Three Lakes, Wis.

Masses: June, Every other Sunday at 10 a. m.

Masses: July 1st to September 1st, 9 a. m. and 10 a. m.

After September 1st, every other Sunday at 10 a. m.

REV. FR. A. A. BORUCKI, Pastor.

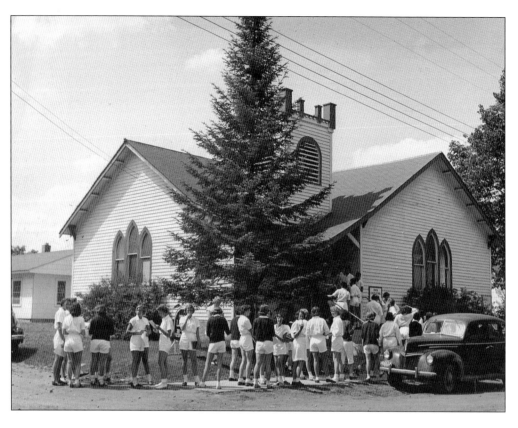

The Union Congregational Church is pictured above during the summer months. Campers from Camp O-Than-Agon are preparing to enter the church for Sunday services. (Both, courtesy of the Three Lakes Historical Society.)

Congregational Church

Three Lakes, Wis.

You are welcome to spend your vacation Sunday morning hour in our little Shrine of the North.

Sunday School_____ 10:00 A. M.
Worship Services_____ 11:00 A. M.

ALVIN LEE KOENIG, Pastor

Visitors welcome!

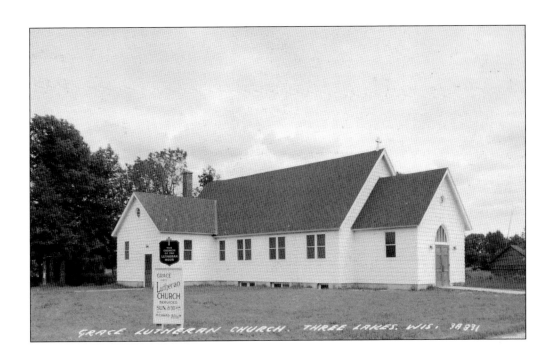

The congregation of Grace Evangelical Lutheran Church first started meeting in the Union Congregational Church and did so until 1950, when their present church, pictured above, was constructed. (Both, courtesy of the Three Lakes Historical Society.)

Grace Evangelical Lutheran Church

Wisconsin Synod, Synodical Conference

Services held in the Congregational church every second and last Sunday in the month.

J. D. KRUBSACK, Pastor

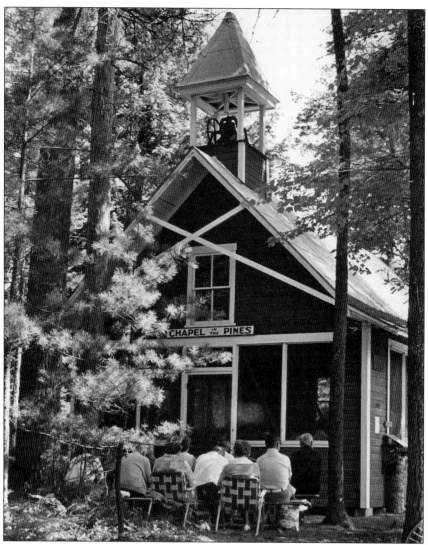

Chapel in the Pines is located on Preacher's Point, a long point of land between Big Fork and Little Fork Lakes. In about 1907, Bert Louk bought the point and adjoining property for back taxes. He then sold the point to two ministers, Rev. L.C. Smith and Rev. Samuel Martin, for $700, and the piece of land became known as Ladysmith Point or more commonly, Preachers Point. Smith bought out Martin, and through word of mouth, he sold lots to preachers and others. On Sundays, because there was no easy way to travel in town, services were held in cottages. In 1924, the Vinden Beach Association expanded to include the maintenance and running of an interdenominational chapel built on common property, which was and is called the Chapel in the Pines. The construction of the chapel was the result of people from surrounding lakes attending services. By 1910, the cottages were no longer able to accommodate the number of people who wished to attend services. Boathouses were then used by placing planks across the boat bays. William Reed of Reed Candy Company in Chicago suggested that the association erect a chapel on association land. The Reeds saw a need for a church, so they drew up a map of the point with each lot marked and named with a $5 for-sale sign on each one. At the next meeting, they placed their map on the wall with the money to be used to build a church. The first service in the chapel was in August 1924. (Courtesy of the Three Lakes Historical Society.)

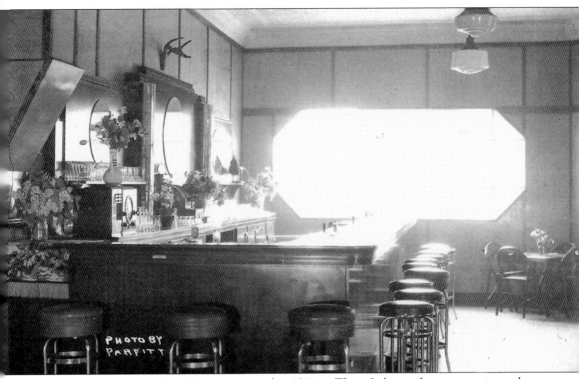

American Legion Post No. 431 was organized in 1944 in Three Lakes and remains active today. The post purchased the Olkowski store for its headquarters, and the building underwent significant renovations. This picture shows the bar as it looked shortly after the post was organized. (Courtesy of the Three Lakes Historical Society.)

Three Lakes Milestones
1901–1910

1904 The Woodruff-McGuire sawmill closes and the machinery is moved to Three Lakes. John H. Korzelius purchases the property and starts a resort on Townline Lake. Maple Lake is connected to the chain by a canal and its level drops by eight feet. Wells in Three Lakes go dry. A thoroughfare is dredged between Townline and Planting Ground Lakes by the Three Lakes Canal and Transportation Company.

1905 The present Burnt Rollways Dam is built to raise the water level in the Three Lakes Chain. John Koshuta starts a marine milk route with a rowboat.

1906 Two rooms are added to the Three Lakes School. Ten grades are taught in Three Lakes. Herman and William Saecker, Mrs. Margaret Richey, and the Rev. Dr. Selden build cottages on Preachers Point and Vinden Beach.

1908 F.S. Campbell Store is dynamited and burned to the ground. Campbell begins potato farming. Three Lakes is saved from another forest fire. Dan Gagen dies. Frank Bonkowski arrives in Three Lakes and begins growing ginseng.

Four

USING AND CARING FOR THE LAND

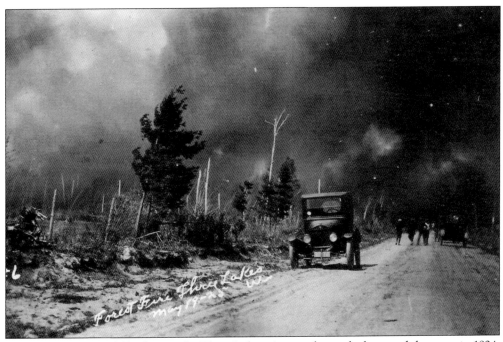

The mid-1920s were difficult years for Three Lakes. A tornado nearly destroyed the town in 1924, and a large forest fire swept through the area in 1925. The region was prone to forest fires during this time because the cessation of large-scale logging operations for pine left much of the area scattered with small slashings from the trees, which became tinder-dry. The forest fire devastated hundreds of acres and destroyed parts or all of many resorts, some of which never reopened. (Courtesy of the Three Lakes Historical Society.)

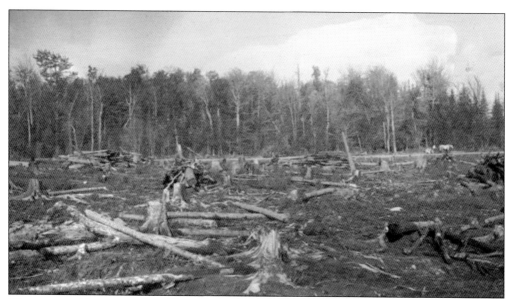

The countryside surrounding Three Lakes was barren of standing timber, except for the few hardwood trees left standing by the logging companies, as there was only a large demand for pine lumber, which was needed for the construction of buildings. These cutover areas often extended up to the shores of the lakes in the Three Lakes chain. Because of the cutover, the price for lakefront property was inexpensive, prompting people looking for homesteading property to move to the area. (Courtesy of the Kloes Collection, Demmer Memorial Library.)

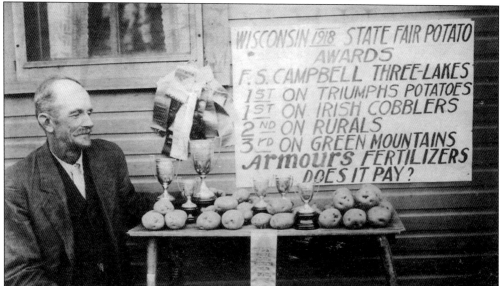

After his store was dynamited and burned to the ground, F.S. Campbell turned his efforts to farming and became one of the area's leading potato farmers on a farm he had purchased a mile south of the village. By 1914, he had become well known in the state as a potato farmer, raising Irish Cobblers, Rural New Yorkers, Green Mountains, and Early Red Triumphs. He won many silver cups and blue ribbons for his potatoes at various competitions. He was also called upon to be a judge on other occasions and to write articles and lecture at farmers' institutes. (Courtesy of the Three Lakes Historical Society.)

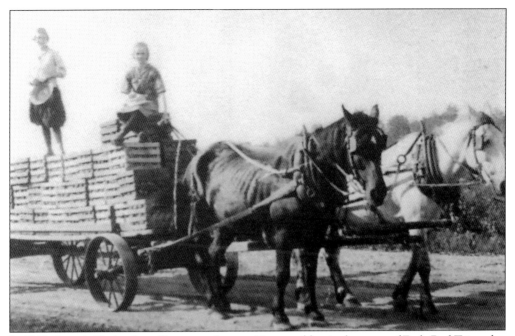

In 1916, Campbell's daughter Florence, who was 13 years old, raised an acre of Early Red Triumphs, which she sold to purchase her own piano. Florence is pictured here sitting on a wagon hauling potatoes to the railroad depot in Three Lakes. (Courtesy of the Three Lakes Historical Society.)

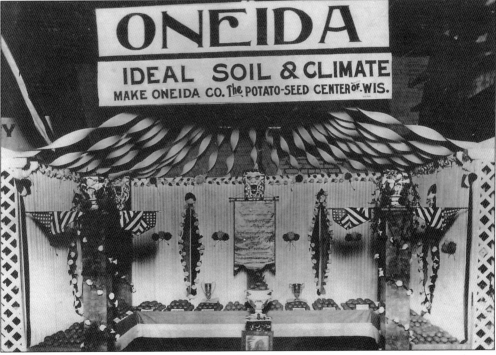

F.S. Campbell was not the only successful potato farmer in Oneida County. The region became famous for its arable soil and climate that was conducive to potato farming. Several large potato farming operations still exist in the county today. (Courtesy of the Three Lakes Historical Society.)

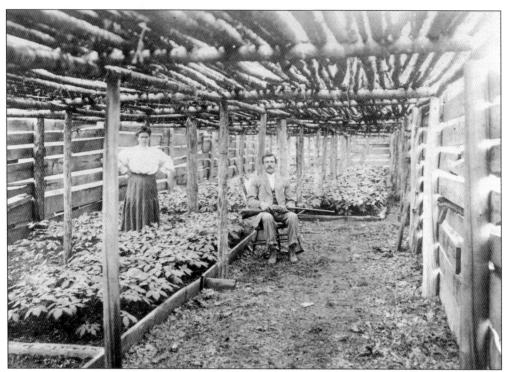

Most people associate agriculture in Wisconsin with corn, potatoes, dairy, and beef. However, ginseng has been around for quite some time. In this photograph, Frank Bonkowski and his wife pose among their ginseng plants. (Courtesy of the Three Lakes Historical Society.)

After the end of the logging boom era in the Three Lakes area, more people turned to farming as an alternative to logging to make a living and support their families. Since much of the area had already been cleared of timber, farmers set to work removing stumps (usually with the help of dynamite) and began to grow a variety of crops both for subsistence and for sale. (Courtesy of the Three Lakes Historical Society.)

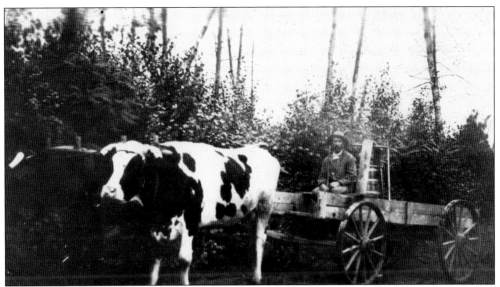

William "Milwaukee Bill" Ritzer and his team of oxen are pictured here. Ritzer owned 87 acres of land on the southeast side of Big Lake. He worked lumber camps in the winter and road building crews and farming in the summer. Dynamite was expensive, so Ritzer had a team of oxen to help with the heavy work. They were not the most practical draft animal, but they did good work in road building in the summer and in the winter when horses could not work. (Courtesy of the Three Lakes Historical Society.)

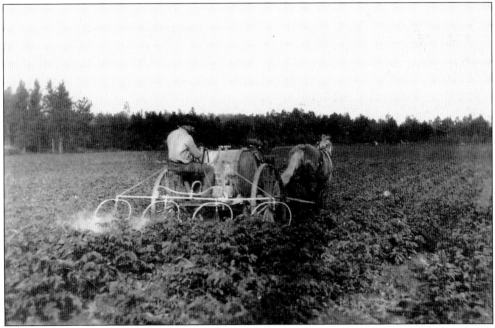

After retiring from baseball, Cy Williams briefly farmed full time until a severe drought, lasting several years, ended his farming career. He then turned his attention and energies to architecture and construction, erecting many homes and large buildings in the area. (Courtesy of the Three Lakes Historical Society.)

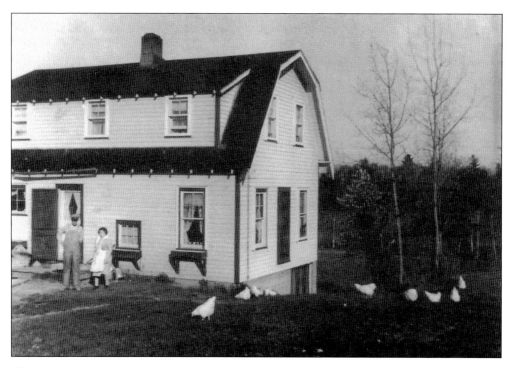

The lumbermen who cut the timber off the property pressured the Wheeler family to buy back the center of Wheeler Island, and they reluctantly did so. They turned a liability into an opportunity by reforesting a wide strip of the cutover land behind the entire frontage so that the road around the island would be forested on both sides. Then they had the inside area cleared of the large stumps and created a farm to supply the cottagers with milk, eggs, vegetables, and even strawberries. They built a good farmhouse, pictured here, and a modern barn, and found farmers to operate it. (Both courtesy of Lois Ralph.)

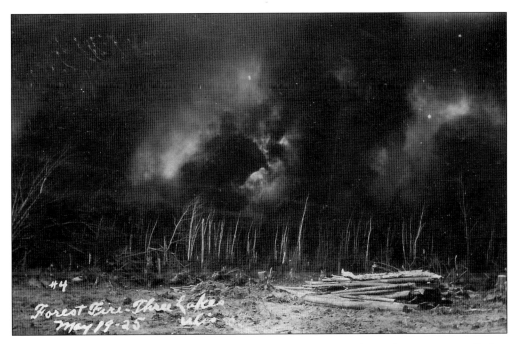

In the years following the end of large-scale logging operations, forest fires were not all that uncommon. One fire at the turn of the 20th century sent the residents of the community into the waters of Maple Lake as the flames threatened to engulf the town. A shift of the winds saved the community. Professional firefighters were en route from Chicago to Three Lakes to provide assistance. The last big fire was in 1925, pictured here, along County Highway X north of Three Lakes. (Both, courtesy of the Three Lakes Historical Society.)

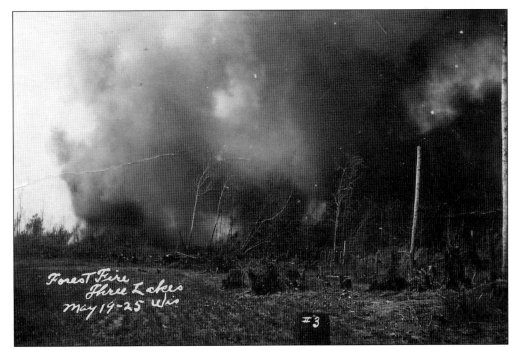

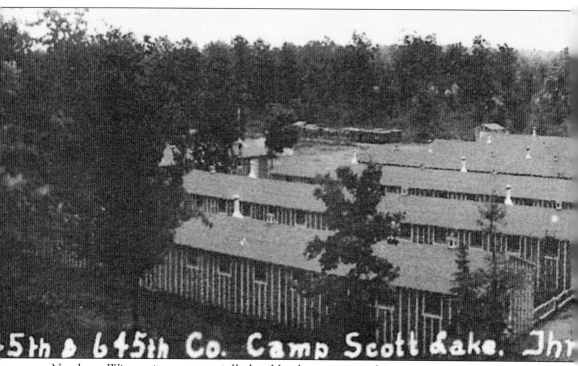

5th & 645th Co. Camp Scott Lake. Jhr

Northern Wisconsin was especially hard-hit by economic depression, unemployment, and severe drought in the 1930s. While early conservation efforts had been aimed at establishing parks and grounds for hunting and fishing, government focus shifted toward rehabilitation in the mid-1930s. The land around Three Lakes was in need of such rehabilitation, and about 22

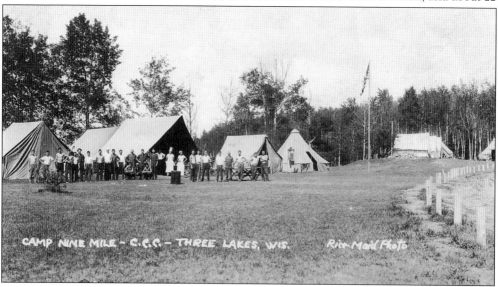

CAMP NINE MILE - C.C.C. - THREE LAKES, WIS. Rice Maril Photo

Camp Ninemile was located northeast of Three Lakes near Upper Ninemile Lake. Like the enrollees at the neighboring camp, the men at Camp Ninemile completed conservation and rehabilitation work, under the supervision of the Nicolet national foresters. They planted pines about eight feet apart. Eventually, as the trees grew, they would be selectively harvested for pulpwood. (Courtesy of the Three Lakes Historical Society.)

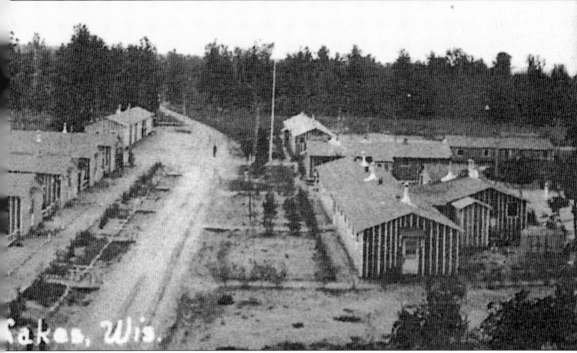

Civilian Conservation Corps (CCC) camps were opened in the tri-county area (Oneida, Forest, and Vilas Counties) to complete conservation work. Camp Scott Lake, located east of Three Lakes, was one of these camps. Each camp had about 200 enrollees. (Courtesy of the Three Lakes Historical Society.)

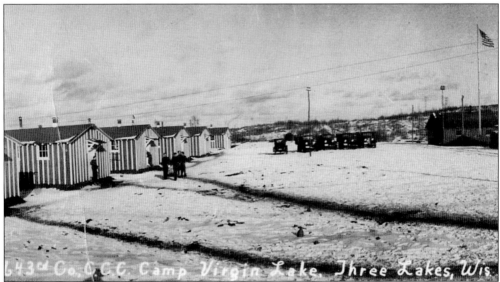

When the CCC began, temporary housing in the form of tents was used to accommodate the men who were sent to the region to work. Work done by the men out of Camp Virgin Lake included forest fire control, tree planting, road construction, and fish and wildlife habitat improvement. Much of the work done by the CCC is still evident today. (Courtesy of the Three Lakes Historical Society.)

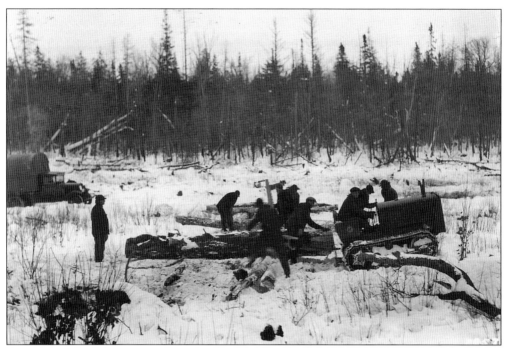

Part of the job of the men working for the CCC involved forest fire control. This consisted of removing timber from fire prone areas. However, these men also planted three billion trees across the nation and helped improve America's infrastructure by building roads and bridges in remote areas. This crew from Camp Virgin Lake is working during the winter months, preparing for the upcoming fire season. (Courtesy of the Three Lakes Historical Society.)

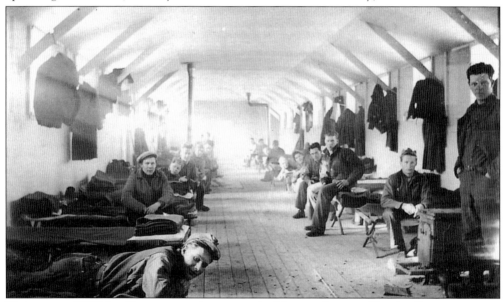

The average CCC bunkhouse was a large open building with rows of bunks. Privacy was at a premium in these bunkhouses, but because the CCC boys had built friendships with those they worked with, time in the bunkhouses was also a time for socialization and camaraderie. (Courtesy of the Three Lakes Historical Society.)

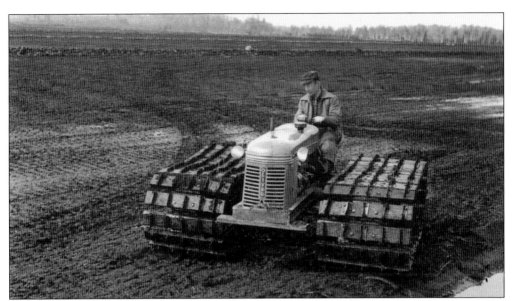

In the summer of 1946, Vernon Goldsworthy and Ralph Sampson arrived in Three Lakes to develop their cranberry bogs. While Sampson and Goldsworthy were not business partners and did not establish a joint partnership, they each were experienced in cranberry farming. Vernon had worked as a sales manager in the Wisconsin office of the Eatmor Cranberry Association. Ralph had worked in the Wisconsin Rapids Eatmor Cranberry office. This image shows the planting of cranberry vines. As the Thunder Lake Cranberry Marsh grew and it was evident that cranberry farming would in fact be successful in the region, a processing plant was constructed and opened in Eagle River. Vernon's younger brother Walter was hired as the manager of the Thunder Lake marsh while Vernon served as general manager of the Fruit Grower's Cherry Cooperative in Sturgeon Bay from 1949 to 1951. (Courtesy of the Three Lakes Historical Society.)

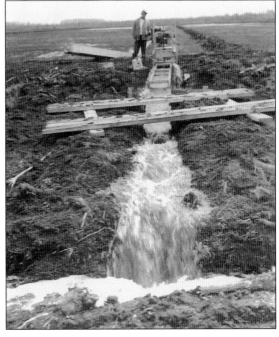

Part of the process of growing cranberries involves flooding the bogs on a seasonal basis. The bogs are flooded at harvest time, and the berries are then harvested. This was originally done manually and required the employment of many workers, but now it has become more of a mechanized process. (Courtesy of the Three Lakes Historical Society.)

Three Lakes Milestones
1911–1920

1914 Angus McDonald establishes Lake Breeze Resort on Townline Lake.

1915 Del Brewster starts an ice business, using gasoline-powered equipment to cut ice. Fred "Cy" Williams moves to Three Lakes to begin farming. He still plays baseball for the Chicago Cubs.

1916 Leo Bishop starts Camp Idyle Wyld for girls. A marine mail route is established.

1917 Minne Wonka Corporation buys the Hotel Laurelton property on Little Fork Lake as a resort. Cy Williams is traded to the Philadelphia Phillies. The United States enters World War I.

1918 A teacherage is located in Three Lakes. The teachers walk to the outlying schools.

1920 Fred Luderus retires from baseball and buys property on Range Line Lake and starts the Hi-Mont Resort, now Camp Luther. Camp Minne Wonka for boys is opened on Virgin Lake by the Ewerhardts. The Three Lakes Volunteer Fire Department purchases a two-wheeled cart that carries a 50-gallon drum and a hand-operated pump. The Thunder Lake Lumber Company establishes its new field headquarters, store, and two-stall engine house where the narrow-gauge railroad crossed Highway 32, east of Virgin Lake, calling it the Thunder Lake Store.

Five

RESORTS AND CLUBS

According to the Wisconsin Historical Society, from 1890 to 1920, Western Vilas County and northwestern Oneida County had the greatest concentration of commercial resorts in the upper Great Lakes. The *Three Lakes, Wisconsin, Visitor's Guide*, published in 1954, issued a cordial invitation to visit the Three Lakes region that summer: "A warm welcome awaits you and you will be delighted with the outstanding hospitality of this region. Come earlier, stay longer, regain new health in the Three Lakes region." (Courtesy of the Three Lakes Historical Society.)

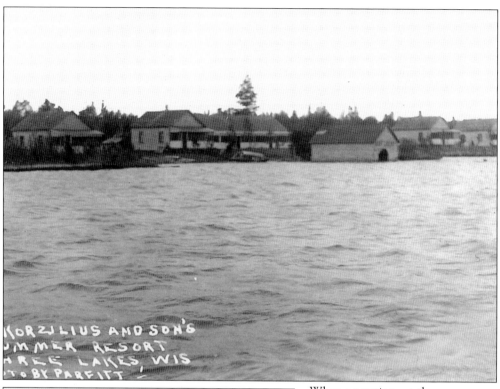

KORZILIUS AND SON'S
SUMMER RESORT
THREE LAKES, WIS
PHOTO BY PARFITT

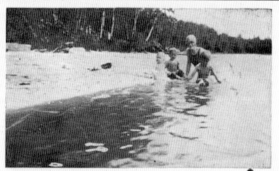

When operations at the Buckwheat Sawmill ceased in 1904, John H. Korzilius purchased the property and buildings and opened the Korzilius and Sons Resort on Townline Lake. (Both, courtesy of the Three Lakes Historical Society.)

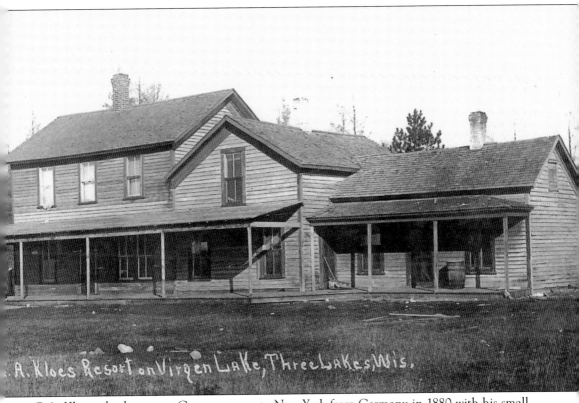

A. Kloes Resort on Virgen Lake, Three Lakes, Wis.

G.A. Kloes, also known as Gustave, came to New York from Germany in 1880 with his small family, which included his wife, Caroline; three-year-old Gustave Adolph, called Adolph; and 10-month-old Emil. In 1893, the family moved to Three Lakes. Gustave homesteaded along Big Lake and opened the Big Lake Resort. In 1899, then 22-year-old Adolph married, and on the shores of Virgin Lake where Hi Polar's original trading post was located he established the G.A. Kloes Virgin Lake Resort (pictured here), which he ran for several years before selling it to open a sawmill. This resort operated for many years simply as the Virgin Lake Resort, eventually becoming Pop's and then Holiday Haven. (Courtesy of the Three Lakes Historical Society.)

Big Lake Resort was first established by Gustave Kloes and his family in 1897. After the death of Gustave in 1903, Emil and Anna Kloes took over and renamed it Pleasant View. It was one of the largest in the area and could accommodate 70 guests. The resort sat on 470 acres and had three miles of frontage on Big Lake. It operated as The Other Place for several years before finally closing. (Both, courtesy of the Three Lakes Historical Society.)

PLEASANT VIEW
RESORT
On Big Lake
MODERN HOTEL AND COTTAGES
Innerspring Mattresses
American Plan or Housekeeping
Safe Sand Beach - Good Fishing and Hunting
12 Cottages — 2, 3, 4, 5 Rooms
Rates $15.00 to $30.00
For reservations write:
Mr. & Mrs. Herbert Quinn Three Lakes, Wis.

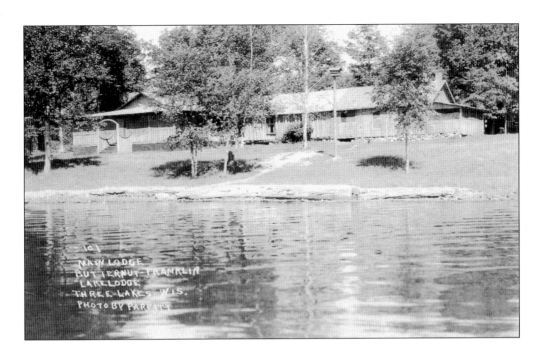

In 1893, the first resort was built on Butternut Lake by Charles French, who operated it for five years. The Butternut Lake Resort was later owned by Wesley Beach, who sold it to Mr. and Mrs. Fournier in 1900. Mr. Fournier was killed in an auto accident in 1919, and in 1920, the resort was sold to G.A. Griswold, who renamed it Griswold's Camp. The dining room at the Butternut Lake Resort, pictured below as it appeared before 1920, featured a number of mounted wild animals, including an albino fawn. (Both, courtesy of the Three Lakes Historical Society.)

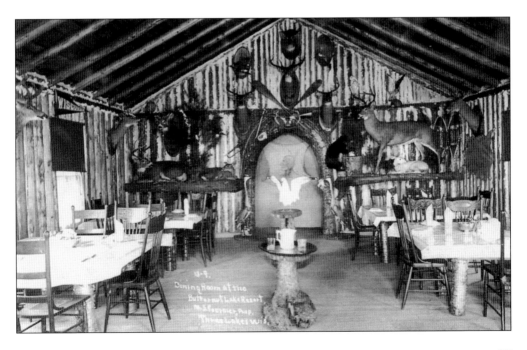

Butternut-Franklin Lodge . . .

Though the Butternut-Franklin Lodge changed ownership many times throughout its existence, each owner maintained the rustic nature of the resort that had appealed to sports enthusiasts and those seeking to escape the hustle and bustle of city life. (Courtesy of the Three Lakes Historical Society.)

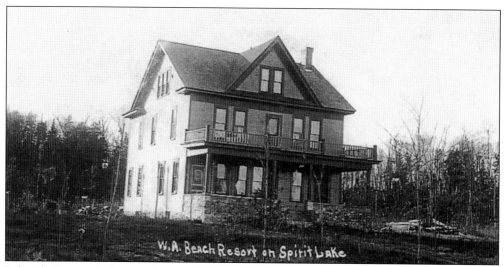

Lakeside Resort on Spirit Lake, pictured here, was built by Wesley Beach after purchasing five acres in 1905. It changed hands several times during the past 100-plus years and is now Bonnie's Lakeside. (Courtesy of the Three Lakes Historical Society.)

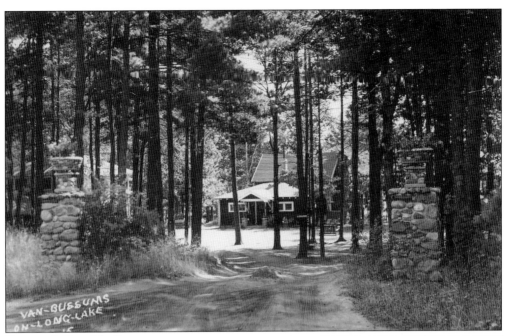

Steve and Clara VanBussum established VanBussum's Resort in 1912. They built the main cottage, and the resort grew to include 17 cottages. Until 1915, when the road was built, the cottages were only accessible by water. They did not have electric lighting until 1933. During the Depression years, Steve chartered a special plane to bring his guests to the area. Steve died at age 92, and the resort was divided into parcels. (Both, courtesy of the Three Lakes Historical Society.)

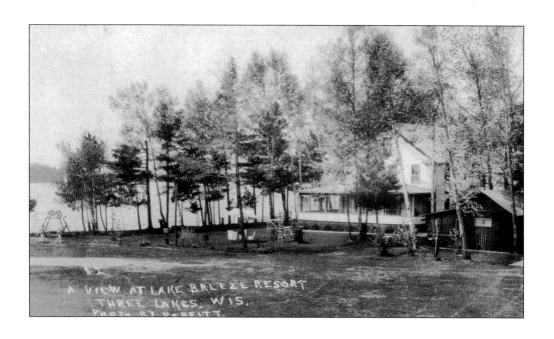

Angus McDonald was probably one of the first serious conservationists in the Three Lakes area. McDonald came to Three Lakes around 1914 and purchased 40 acres of timberland on the north shore of Townline Lake, where he built and established Lake Breeze Resort. The resort was well known and was one of a few to survive throughout the years with continuous success. The resort finally closed in 1997. (Both, courtesy of the Three Lakes Historical Society.)

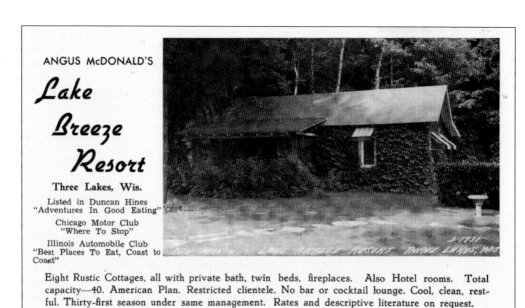

ANGUS McDONALD'S

Lake

Breeze

Resort

Three Lakes, Wis.

Listed in Duncan Hines
"Adventures In Good Eating"

Chicago Motor Club
"Where To Stop"

Illinois Automobile Club
"Best Places To Eat, Coast to Coast"

Eight Rustic Cottages, all with private bath, twin beds, fireplaces. Also Hotel rooms. Total capacity—40. American Plan. Restricted clientele. No bar or cocktail lounge. Cool, clean, restful. Thirty-first season under same management. Rates and descriptive literature on request.

"MODERN AS TODAY'S NEWSPAPER" "SMALL BUT SMART"

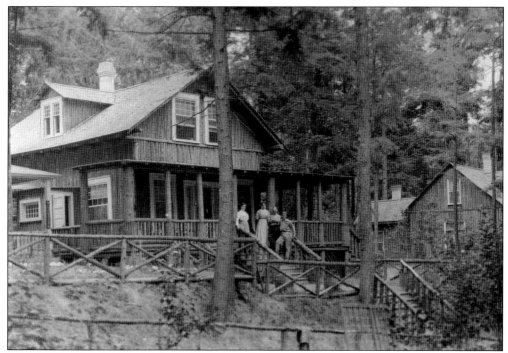

Pictured above is the Blue Ribbon Resort guest lodge around 1913. In 1905, Otto and Pauline Roderwald purchased 146.5 acres on Island Lake, and eventually constructed a rustic-style resort, one of the first in the area. One building contained a large sitting room and spacious bedrooms. The resort accommodated 25 guests, who arrived via the Chicago & Northwestern Railway. Two trains arrived in Three Lakes daily. Otto Roderwald died in March 1909, and his wife, Pauline, continued to run the resort with the help of her six children and their families. The tornado of 1924 took down all the trees on the Blue Ribbon Resort property and badly damaged the buildings. The following fall, a fire swept through the entire area. The houses were burned to the ground; the Blue Ribbon Resort did not reopen after the forest fire. (Both courtesy of Bill Schliep.)

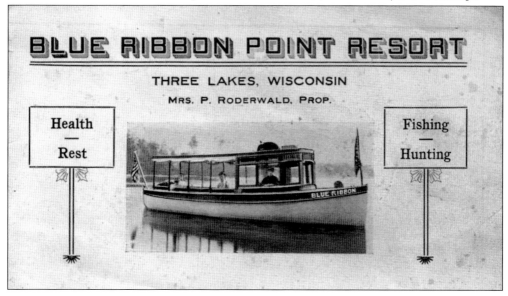

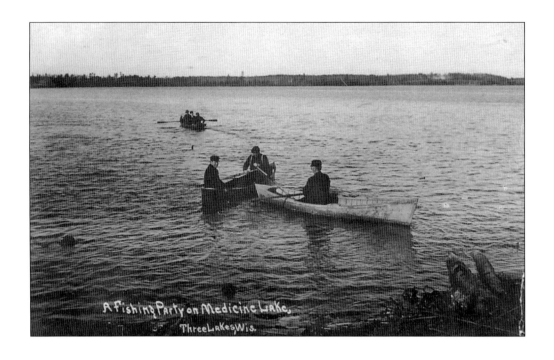

A Fishing Party on Medicine Lake, Three Lakes Wis.

Medicine Lake Lodge opened as a summer resort in 1921, operated by the Birchwood Resort Company of Three Lakes. The resort became a popular destination for fishermen and was operated until the early 1970s, at which time it was converted to condominiums. It was the first resort-condominium conversion in the state. (Both, courtesy of Dave and Jan Hintz.)

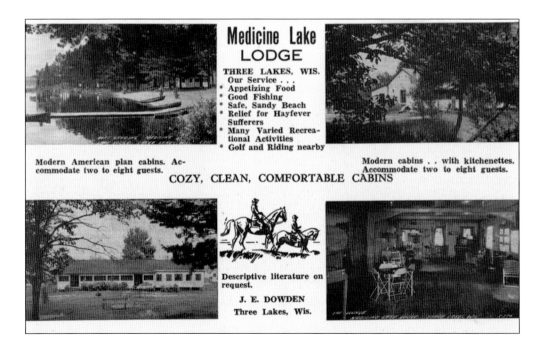

Medicine Lake LODGE

THREE LAKES, WIS. Our Service . . .
* Appetizing Food
* Good Fishing
* Safe, Sandy Beach
* Relief for Hayfever Sufferers
* Many Varied Recreational Activities
* Golf and Riding nearby

Modern American plan cabins. Accommodate two to eight guests.

Modern cabins . . with kitchenettes. Accommodate two to eight guests.

COZY, CLEAN, COMFORTABLE CABINS

Descriptive literature on request.

J. E. DOWDEN
Three Lakes, Wis.

John Motylewski came to Three Lakes in 1899. He brought his wife and children from Minneapolis and bought 40 acres on Spirit Lake at $1.25 per acre. His son Adam, pictured here, built Adam's Cabins Summer Resort on Highway 32 near Spirit Lake. Motylewski's resort was very popular among visitors to Three Lakes. (Courtesy of Cynthia Motylewski Lake.)

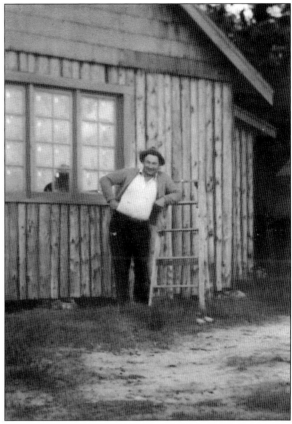

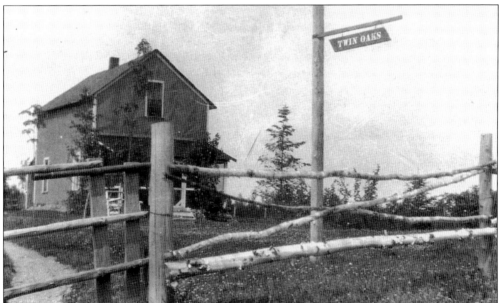

Twin Oaks Resort on Crooked Lake was built by Fred Lohagen and was purchased by Oscar Lawonn in 1923. Lawonn sold it in 1940. Twin Oaks is pictured here in 1925. (Courtesy of the Three Lakes Historical Society.)

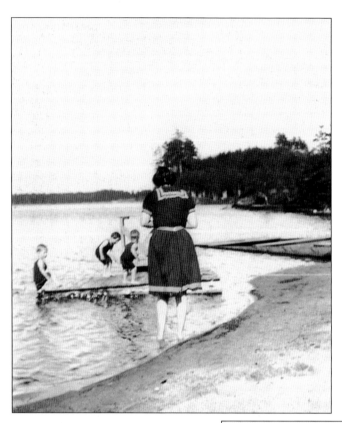

Three Lakes was not just a destination for sportsmen. It was also a place where families could come and enjoy time away from city life. While men might have come to the area to fish and hunt, their families could spend time enjoying the sun and fresh air at the lake, as seen in this photograph from the early 1920s. (Courtesy of the Three Lakes Historical Society.)

As more sportsmen came to the area, a lucrative business opportunity developed for men who lived in the area to work as guides. This advertisement features some of the more well-known guides of the community. (Courtesy of the Three Lakes Historical Society.)

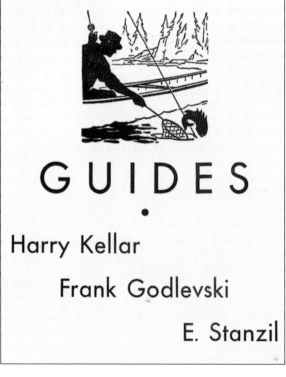

GUIDES
.
Harry Kellar

Frank Godlevski

E. Stanzil

It was not just men who came to Three Lakes to land a big one. Many women who visited the area also caught trophies from area lakes. (Courtesy of the Three Lakes Historical Society.)

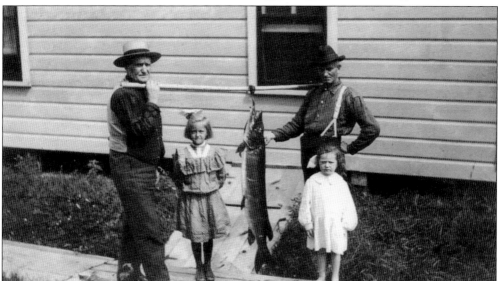

This photograph of visitors at the Lakeside Resort is a good example of how good the fishing was in the lakes that made up the Three Lakes Chain. During this period, the Chicago & Northwestern Railroad ran a Fisherman's Special that brought fishermen to the communities of Wisconsin's Northwoods for a weekend of fishing. (Courtesy of the Three Lakes Historical Society.)

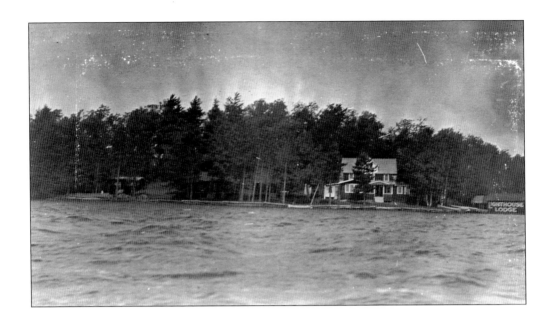

Lighthouse Lodge, formerly known as Oak Grove Resort, was located on Planting Ground Lake and opened for business in 1912. It consisted of a main lodge and seven cabins. It was named Lighthouse Lodge because of the small lighthouse anchored out in the channel, which is no longer there. The resort was sold in 1920. (Courtesy of the Three Lakes Historical Society.)

Fishing	Children's
Boating	Playground
Bathing	Safe Beach
Hiking	Excellent Food
Sailing	Modern Cabins
Tennis	
Golf	Member of
Shuffleboard	Wisconsin Hotel
Ping Pong	Association
Diving Raft	
Aqua-Planing	
Horseback	
Riding	

LIGHTHOUSE LODGE
"Your Family Summer Home"

THREE LAKES - WISCONSIN

Lighthouse Lodge is located in the "Hub" of the Famous Eagle Chain of twenty-seven connecting lakes. Midway between Three Lakes and Eagle River. Restricted clientele.

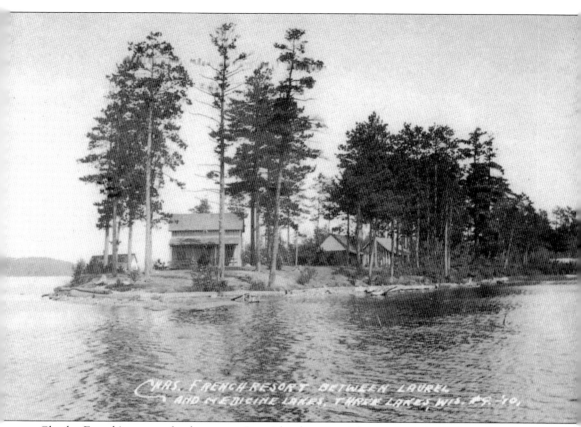

Charles French's resort, also known as Pine Island or Pine Isle, was built in 1898 on the island between Laurel and Medicine Lakes. The island is now known as Denby Island and has a much larger home on it that was built by the Allens when they resided there. (Both, courtesy of the Three Lakes Historical Society.)

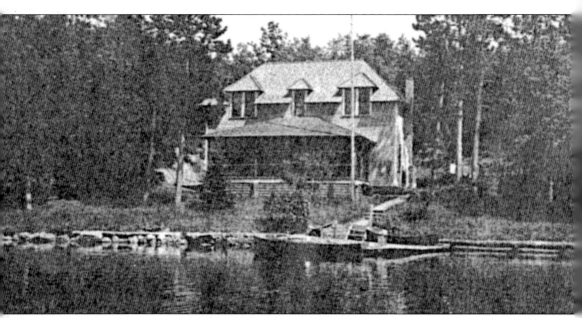

The Indianapolis Outing Club was located on Planting Ground Lake and was built by Burton Swain and six other men from Indiana and Kentucky who purchased the land on the east shore of the lake. Contrary to popular reports, this club was not a sanctuary for Democratic politicians; rather, it was used as a haven for sports enthusiasts who were businessmen, bankers, and other professionals, mostly Republicans, who enjoyed the climate and recreation opportunities of northern Wisconsin. This photograph shows the main lodge of the club as it appeared in 1910. (Courtesy of the Three Lakes Historical Society.)

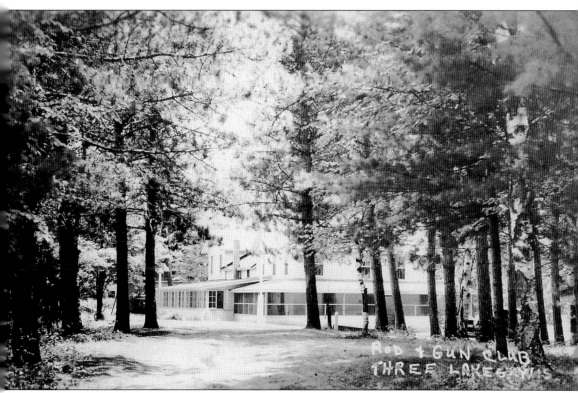

Three Lakes is perhaps the birthplace of one of the first condominium concepts in the nation. In June 1884, a group of sportsmen from Batavia, Illinois, who camped on Lake Gogebic, near present-day Bergland, Michigan, the "Gogebic Club" as they were known, materialized into what has become known as the Rod and Gun Club of Three Lakes. These individuals were looking for the ideal spot at which to establish a club to fish, hunt, and enjoy good fellowship and to get away with their families. In 1886, this group arrived in Three Lakes as a result of hearing of the natural beauty of the largest chain of lakes in the world. The group first stayed on Charles French's point, now known as Denby Island, sleeping in tents on balsam boughs covered with blankets. On September 27, 1898, an organizational meeting was held to buy the property that the club now occupies. The main lodge of the Rod and Gun Club is pictured here. The club encompasses about 60 acres of land. (Courtesy of the Three Lakes Historical Society.)

Three Lakes Milestones

1921–1930

1921 Leslie Lyon and his wife, Viola, start Minne Wonka Lodge, a girls' camp, on Little Fork Lake. Fred H. Dobbs, who formerly owned a general store in Conover, starts a Red Owl grocery store in Three Lakes.

1922 The Congregationalists purchase the Methodist church.

1923 The State Bank of Three Lakes is closed and reopened as People's State Bank of Three Lakes.

1924 A tornado destroys much of Three Lakes and severely damages many resorts.

1925 A forest fire threatens Three Lakes and destroys the Blue Ribbon Resort.

1926 The first snowmobile derby is held on Range Line Lake as a part of the Three Lakes Winter Carnival.

1929 Sam Campbell starts making nature films and is hired as a lecturer by the Chicago & Northwestern Railroad. The Thunder Lake Lumber Company is at its peak, employing 900 people.

1930 The area is hit by its worst drought in history, and the Great Depression grips the nation.

Six

GETTING THERE

Many years ago, winter in Three Lakes was much more challenging than it is today. During any given winter, the average snow depth could range from five to seven feet with drifts over 12 feet high, making travel rather difficult. The pleasure of riding in a car was confined to the summer months, and when fall came, residents would carefully take off tires and place their cars on blocks for the winter. (Courtesy of the Three Lakes Historical Society.)

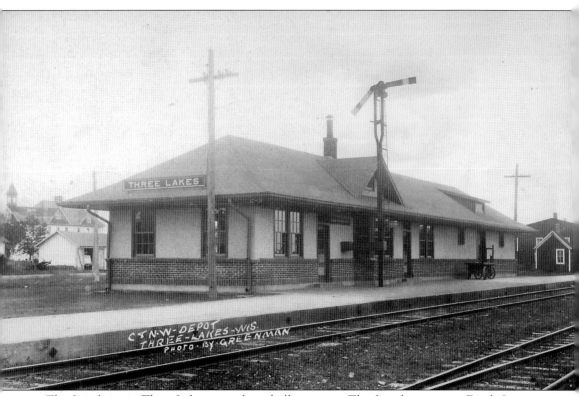

The first depot in Three Lakes was a large hollow stump. The first depot agent, Frank Steiner, used the stump to do his paperwork until the railroad company brought in a boxcar to serve as a temporary depot. The permanent depot, pictured here, appears as it looked around 1920 until it was badly damaged by the tornado in 1924. It was later repaired. (Courtesy of the Three Lakes Historical Society.)

WISCONSIN-UPPER MICHIGAN
SUMMER OUTINGS

CHICAGO AND NORTHWESTERN SYSTEM

The influence of the railroad in the development of the community of Three Lakes cannot be understated. From its early founding to the development of a thriving vacation destination, the railroad was the backbone of the town. This Chicago & Northwestern Railroad brochure from the 1930s featured the resorts of Three Lakes and promoted the region as an ideal destination. Brochures advertised Three Lakes as having "cool nights, sunny warm days and the deep peace and quiet of unbroken wilderness to the thousands suffering in the oppressive heat of the cities. Only an overnight journey on a luxurious Pullman, a pleasant trip on air-conditioned, daylight streamliners, Three Lakes is certain to be the instant choice of all who want to get away from the stifling, uncomfortable city." (Courtesy of the Three Lakes Historical Society.)

According to residents who remember the days of passenger trains in Three Lakes, the depot was always a hub of activity, with people coming and going to all parts of the country. Many locals would try to be at the depot when the evening train arrived. (Courtesy of the Three Lakes Historical Society.)

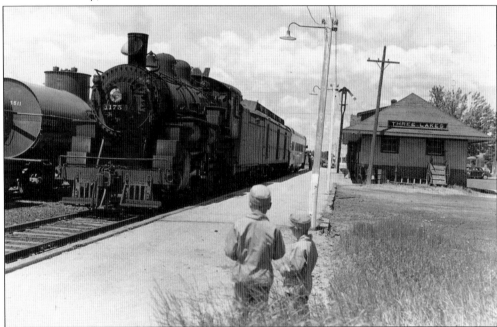

Two aspiring locomotive engineers admire a southbound steam locomotive carrying passengers and freight around the mid-to-late 1940s. Train watching was a common pastime among residents, especially young enthusiasts such as these. According to Florence Zembinski, "one special treat would be to see the 'Limited' come in the evenings. Some men in the caboose would sometimes throw pennies to us kids. That made us so happy. We appreciated those little things so much. We'd get a nickel a week for an ice cream cone and occasionally a sucker. I was so happy with it." (Courtesy of the Three Lakes Historical Society.)

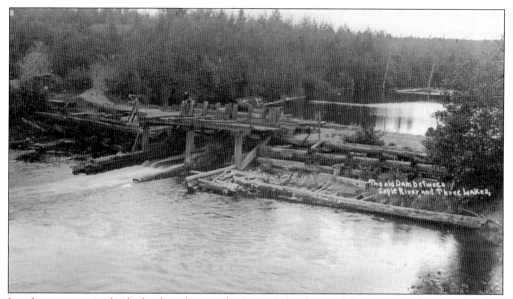

Lumber companies built the first dam in the Long Lake thoroughfare to raise the water level in the chain of lakes so that all of the thoroughfares could be used to carry logs to the mill being constructed north of Three Lakes at Buckwheat. Prior to building the dam on Long Lake, the chain of lakes was too low for the tugboat to haul booms of logs to the mill. The first dam, pictured here, was constructed in 1899 and was a rather squat-looking structure made of large logs. (Courtesy of the Three Lakes Historical Society.)

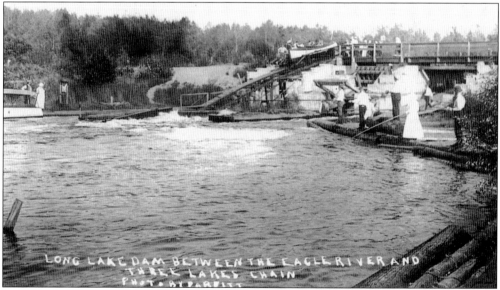

In 1907, the Wisconsin Valley Improvement Company obtained water rights and control of all the water draining into the Wisconsin River System through a referendum. This affected 21 lakes above the dam. The Wisconsin Public Service Company built Burnt Rollways Dam below the old log dam to make the channel navigable to Eagle River. The dam raised the lakes' level higher than the lumber company dam, and a larger reservoir was formed. The original tramway and boat lift was at Burnt Rollways Dam. The churning water below the dam made for good fishing. (Courtesy of the Three Lakes Historical Society.)

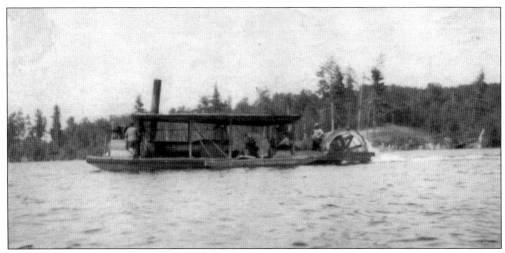

The paddleboat owned by the Three Lakes Canal and Transportation Company is shown here. This boat was the dredge that was used to make the passage between Maple Lake and the rest of the Three Lakes Chain. (Courtesy of Lois Ralph.)

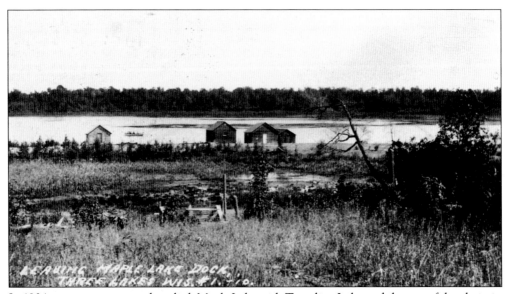

In 1904, an attempt was made to link Maple Lake with Townline Lake and the rest of the chain in order to make it easier to move people and supplies through the lakes. The project resulted in large mudflats in the lake and cattails in the slough, pictured here in the foreground. This experiment was part of several different attempts to link all the lakes together. Maple Lake would later be restored to a more substantial size. This photograph was taken near where Cy Williams Park and the swimming beach are located today. (Courtesy of the Three Lakes Historical Society.)

This is an early photograph of Wheeler Island Road. Most of the roads in the area were generally two-track dirt roads with grass growing down the center. All the roads were constructed of some sort of rock, gravel, or sand, and were generally built around large trees because the builders of the roads did not want to take the time to fell the trees and haul them away. Some roads in the area, such as Stella Lake Road, were partially corduroy roads through swampy areas. Corduroy roads were laid on a base of cut logs placed side by side and then covered by sand, rocks, or gravel. (Courtesy of Lois Ralph.)

The road to Spirit Lake was rather rustic in 1905. Spirit Lake can be seen here from the top of what was Consumption Hill at the junction of County Highway X and Highway 32. At left was the homestead of Stanley and Anna Tomaszewski. According to records, Consumption Hill earned its name when members of early families fell victim to consumption, as tuberculosis was then called, and were buried on top of the hill. (Courtesy of the Three Lakes Historical Society.)

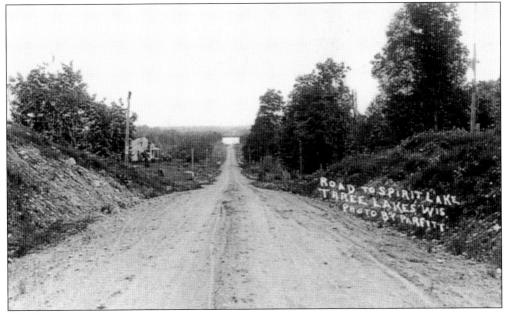

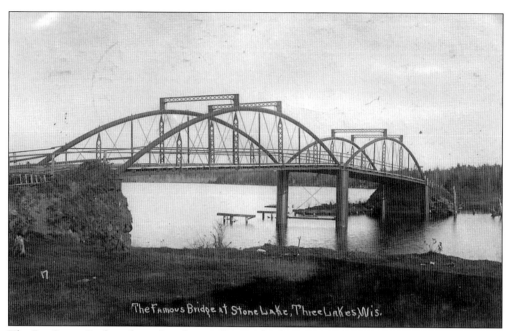

The Big Stone Bridge, also referred to as the iron bridge, spanned the thoroughfare between Big Stone and Deer Lakes. The construction of a bridge between these two lakes linked the area east of Big Stone Lake with the area to the west, making travel by road to these lakes and resorts more feasible. The former Showboat and Northernaire Hotel and Spa were located near the iron bridge. (Courtesy of the Three Lakes Historical Society.)

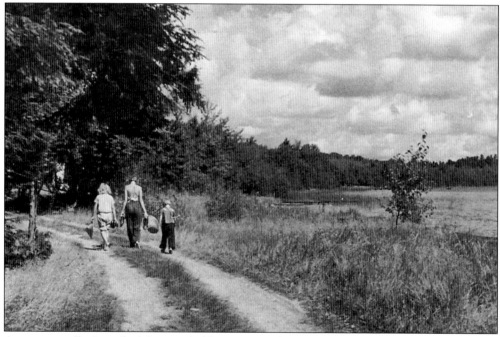

A summer walk along the lake is probably a memory shared by most locals and countless visitors who have called Three Lakes their summer home. Spirit Lake, pictured here, has provided visitors to its shores with picturesque scenes during all seasons. (Courtesy of Cynthia Motylewski Lake.)

Winters in northern Wisconsin require residents to be sturdy and resolute. Of course, it does not hurt to have a little help. Pictured is the Town of Three Lakes' large Wausau plow clearing roads near Clearwater Lake during the winter of 1928. In those years, keeping the roads cleared for traffic was a constant struggle. (Courtesy of the Three Lakes Historical Society.)

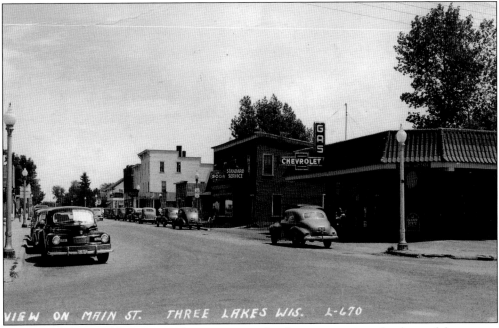

As automobile travel began to replace commercial rail transportation, the demand for garages to complete repairs on vehicles increased in towns all over the state, particularly in popular destinations like Three Lakes. For many years, Ed Epler ran the Badger Garage, which was located near the intersection of US 45 and County Highway A. (Courtesy of the Three Lakes Historical Society.)

Three Lakes Milestones

1931–1940

1931 Electric power is provided to the Town of Three Lakes. Cy Williams retires from baseball.

1932 Fire towers at Hiles, Lake Julia, and Anvil Lake are built.

1933 Franklin D. Roosevelt creates The Civilian Conservation Corps (CCC), and multiple camps are opened around Three Lakes.

1934 The Adventist School in Clearwater Lake burns down.

1935 The Adventists rebuild their school.

1937 Emil Jorgensen buys Sunset Farms in Clearwater Lake and renames it Oneida Farms.

1939 The WPA constructs the Blue Ribbon Bridge between Island and Little Fork Lakes and Highway X. The WPA adds a new gymnasium to the Three Lakes High School, and the school becomes a consolidated grade school and high school.

1940 Potawatomi Indian Chief John Shopodock freezes to death near his cabin on the north branch of the Pine River and is buried in Wabeno.

Seven

GOOD OLE SUMMERTIME

Youth summer camps became a
part of Three Lakes in the early
1900s, and the boys and girls
who spent their summers at these
camps developed strong and
lasting relationships with their
fellow campers and the staff. This
invitation is to the 1938 reunion
of campers from Camp Idyle Wyld.
Most campers who attended camps
in Three Lakes during the peak
years of the summer camp era,
when camps such Minne Wonka,
Idyle Wyld, O-Than-Agon, and
Ray Meyer's Basketball Camp were
open, are now in their early sixties
to late eighties, and many still
travel to Three Lakes on vacations
or have become seasonal or full-
time residents of the community.
Camp Honey Rock and Camp
Luther are the two major summer
camps remaining in the Three
Lakes area. (Courtesy of the
Three Lakes Historical Society.)

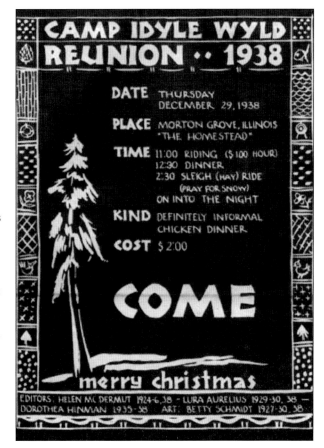

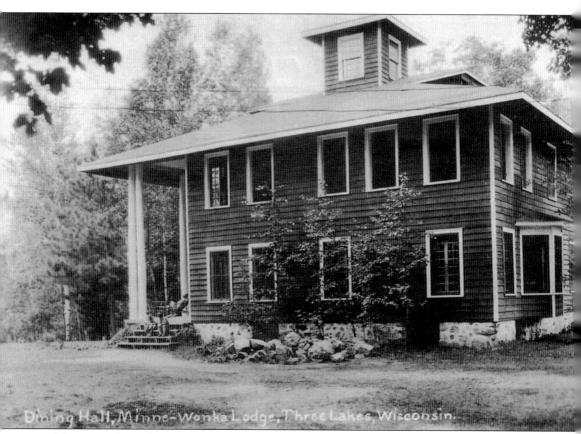

Dining Hall, Minne-Wonka Lodge, Three Lakes, Wisconsin.

Minne Wonka Lodge was a camp for girls founded in 1921 by Leslie and Viola Lyon. In 1918–1919, the Minne Wonka Corporation bought property on Big Fork Lake, which had been a small resort, called the Laurelton Hotel. The corporation first operated the property as a resort for the parents of the boys who were attending Camp Minne Wonka for boys on Virgin Lake. The girls' camp, Minne Wonka Lodge, opened in 1921. The road from Three Lakes to the camp was two dirt tracks with grass growing down the middle. (Courtesy of Karen Connolly Miller.)

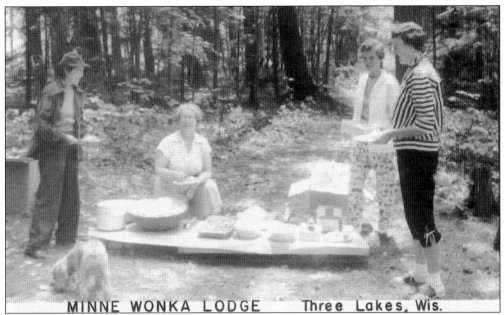

MINNE WONKA LODGE Three Lakes, Wis.

According to former camper Karen Connolly Miller, Sundays at Minne Wonka Lodge were more laid back. Often, the campers and staff would have picnic lunches or dinners consisting of hot dogs, potato salad, and hamburgers. These picnics were accompanied by games and singing. Karen's mother, Pat, a home economics teacher in the Duluth, Minnesota, public schools, was employed as the camp's dietician during the summer months and is pictured in the white dress. (Courtesy of Karen Connolly Miller.)

Part of the end of the season ritual at Camp O-Than-Agon involved a "wishing ceremony," in which the campers, both young and old, would light a candle, place it on a small boat, make a wish for the future, and set it a-sail. One camper shared her wish after the fact and admitted to wishing for her breasts to develop before next summer! (Courtesy of the Three Lakes Historical Society.)

Part of the experience for the girls at most summer camps involved learning outdoor skills such as camping, orienteering, horseback riding, swimming, canoeing, and first aid. In this picture, campers at O-Than-Agon are learning how to sail. The girls who camped at O-Than-Agon, most now in their late fifties and older, have shared their memories when visiting in Three Lakes and all comment about the strong and enduring friendships and important lessons about life they learned while at camp. (Courtesy of the Three Lakes Historical Society.)

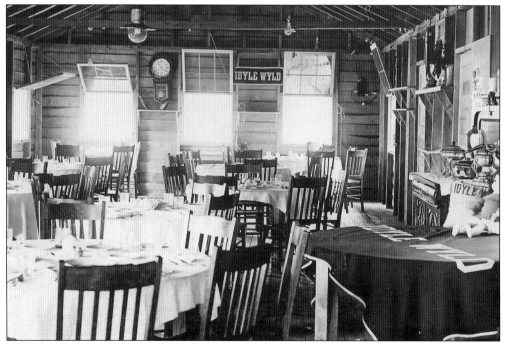

The Camp Idyle Wyld dining hall was a very simple unfinished frame building. At the time this picture was taken, it had a combination of gas and electric lights. Camper meals were plentiful, as the girls led a very active lifestyle. (Courtesy of the Three Lakes Historical Society.)

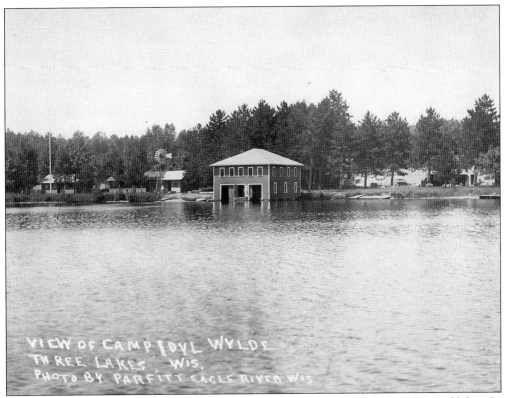

The Camp Idyle Wyld boathouse is an iconic feature on the Three Lakes chain of lakes. In 1915, Leo Bishop married Feicitas Saleski, a Three Lakes schoolteacher, and the two of them established Camp Idyle Wyld, a summer camp for girls, in 1916. (Courtesy of the Three Lakes Historical Society.)

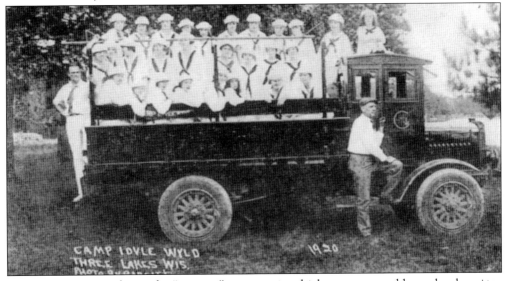

Most summer camps featured a "tripping" program, in which campers would travel to locations for camping, hiking, and other outdoor activities. In this picture from 1920, the campers appear in their uniforms with camp counselors. (Courtesy of the Three Lakes Historical Society.)

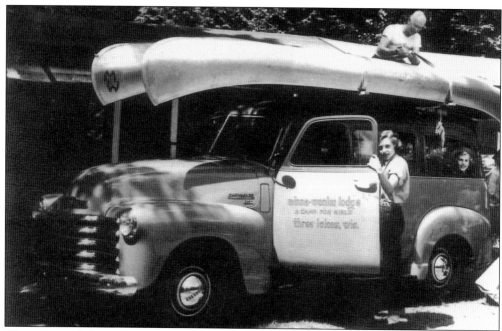

The main goal for Camp Minne Wonka was to instill the joy and adventure found on canoe camping trips and the satisfaction of living comfortably and simply outdoors with a minimum of equipment and simple food. To achieve these goals, the campers would become "trippers" and travel by canoe through the Three Lakes chain. They would also take longer road trips to places such as the Porcupine Mountains in Michigan's Upper Peninsula. The truck pictured here was used to transport supplies for the campers on their various excursions. (Courtesy of Karen Connolly Miller.)

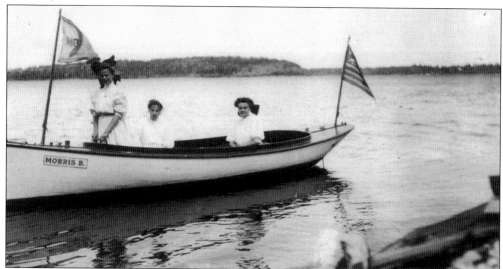

Summertime on the picturesque Three Lakes chain has changed little since people started visiting the area and building summer homes. Scenes of families boating, waterskiing, fishing, or enjoying the sun and fresh air are just as common now as they were in the early years of the town's existence. Lois Ralph shared this picture of the *Morris B.* from the Wheeler family's photo collection. (Courtesy of Lois Ralph.)

As families purchased lakefront property on the chain, they made trips to Three Lakes to build their lake homes. As they did so, they camped in tents and cooked outdoors, as seen here, until their home was complete. (Courtesy of Lois Ralph.)

Excellent fishing continues to draw people to Three Lakes. This photograph, taken around 1912, features what appears to be a married couple with a guide fishing at Ladysmith Point. Make note of who is rowing the boat. Hopefully she did not have to clean the fish as well! (Courtesy of the Three Lakes Historical Society.)

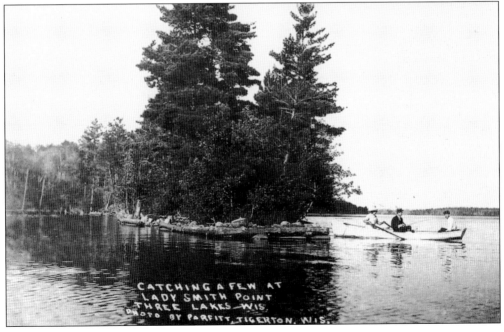

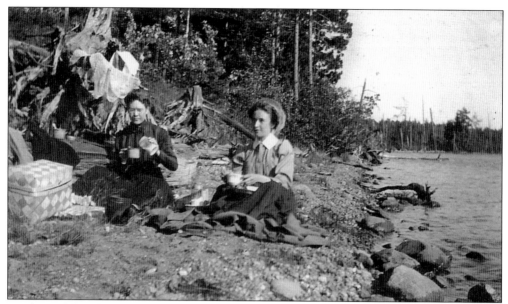

By the middle of the second decade of the 1900s, the area had become a popular vacation destination, and outdoor activities were enjoyed by both genders. This image of two unidentified picnickers was taken on the shore of Big Fork Lake. The area was still quite rugged, as shown by the landscape in the background. (Courtesy of the Three Lakes Historical Society.)

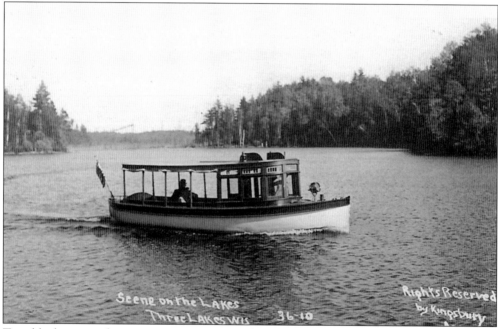

Travel by boat was the easiest way to get around at the beginning of the 20th century, as most roads were merely two-track dirt roads that wound through the outlying regions and were subject to washouts during heavy rains. Steamboats, such as the one pictured here owned by the Spencers, were used to ferry people from the main dock at Maple Lake to their destinations on the chain of lakes. Most resorts offered ferry service to their customers. (Courtesy of the Three Lakes Historical Society.)

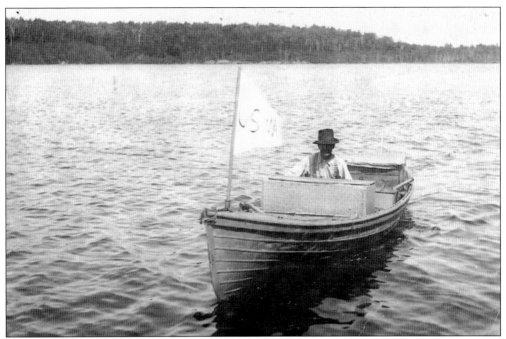

The first government contract for a marine mail route was awarded to Allie Beach around 1910. He used a wheelbarrow to carry the mail to the Maple Lake Dock. His route had 75 stops and covered the entire government-charted area, and it took him all day to make the trip in his one-cylinder gas-powered metal boat. (Courtesy of the Three Lakes Historical Society.)

Emil Zembinski served as a marine mailman from 1946 to 1965. His mail route had 250 stops at its peak. Zembinski used a Higgins 135-horsepower boat, which he called *The Clipper*, to complete his deliveries and would offer people rides as he completed his route. (Courtesy of Bob Zembinski.)

Three Lakes Milestones

1941–1955

1941 The Thunder Lake Narrow Gauge Railroad is shut down. Maple Lake Dam is built, and the water level rises by 4 feet, 10 inches.

1942 Carl Marty builds the Showboat nightclub on Highway 32 near Big Stone Lake.

1943 German prisoners of war work at Oneida Farms due to the labor shortage caused by the war. Carl and Bob Marty build their resort villas on Deer Lake.

1944 American Legion Post No. 431 is organized in Three Lakes and acquires Olkowski store for its headquarters.

1946 Camp Luther is started. The Thunder Lake Cranberry Marsh is opened. The Three Lakes Women's Club is organized.

1947 The Northernaire Hotel is built by Carl and Bob Marty and opens for business in 1948. Fred "Cy" Williams is the architect.

1948 Joint School District No. 1 is formed to consolidate the schools in the townships of Three Lakes, Monico, Sugar Camp, and Piehl. The high school is located in Three Lakes.

1949 The Three Lakes Sportsmen's Club is organized to promote environmentalism.

1950 Grace Lutheran Church is built on its present site.

1955 Carl Marty develops the Sheltered Valley Ski Area.

Eight

PUTTING THREE LAKES ON THE MAP

Sam Campbell was born on August 1, 1895, in Watseka, Illinois. As a young boy, Campbell showed great interest in nature. He visited Three Lakes for the first time in 1909, and at the age of 20, he began to write nature articles for newspapers and magazines. Sam moved to Three Lakes in 1937 and purchased an island in Fourmile Lake, northeast of town, where he constructed a small home. (Courtesy of the Three Lakes Historical Society.)

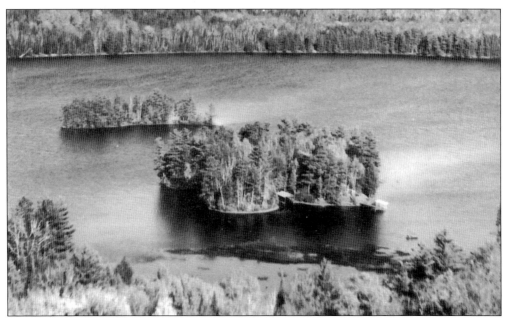

Sam Campbell named his island home "Wegimind," which is the Ojibwe word for mother. Campbell did so to honor his mother, who had passed away, and who also played an important role in introducing Sam to nature and the Northwoods that he loved. It was at Wegimind that he would continue to make his films on animal life and nature and present them to the public. The central theme of his films and presentations was conservation. The interest in Campbell's work was immediate and widespread, and he became known throughout the country as one of its preeminent conservationists. (Courtesy of the Three Lakes Historical Society.)

Sam Campbell married Virginia "Giny," and together they worked to promote conservation and a love of the natural world. They prepared most of his essays on nature and the photography used to illustrate his writing and lectures at their island home, Wegimind. Sam was the author of 12 books on subjects dealing with the outdoors and also made a series of films on animal life that were used by the Chicago & Northwestern Railroad as promotional material and by Campbell to teach the American public about the importance of conservation. (Courtesy of the Three Lakes Historical Society.)

Sam was known as "the Philosopher of the Forest," and when in Three Lakes, he could often be found walking amidst the serenity of his island sanctuary or hiking with friends he had made in Three Lakes. This photograph is of Sam with his friends the Cunninghams on a hiking and camping trip. (Courtesy of the Three Lakes Historical Society.)

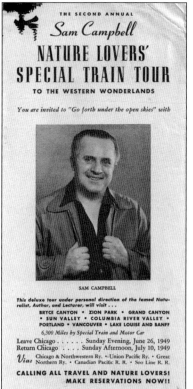

The Chicago & Northwestern Railroad hired Sam as its official lecturer, a position he held for 22 years. He led tours throughout the United States on the railroad to the nation's most natural and scenic areas and developed a large following. Many who traveled with Sam and Giny did so on multiple excursions and developed a strong and lasting relationship with the Campbells and others who traveled with them. (Courtesy of the Three Lakes Historical Society.)

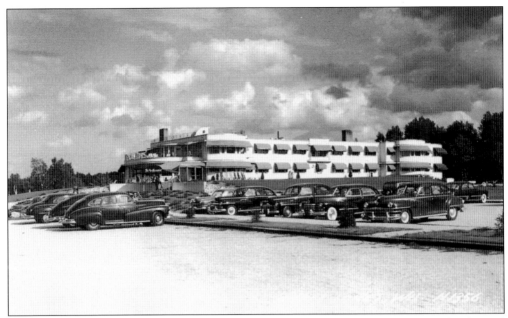

Many people claim that a "golden era" of the Northwoods resort industry was ushered in by Carl O. Marty Jr. with the construction of the Northernaire Hotel and Spa complex on Big Stone and Deer Lakes. Carl and his brother Bob built the Northernaire in 1947 and opened it in 1948. The Villas and Showboat were constructed in the early 1940s, but construction of the hotel had to be delayed due to the onset of World War II. (Courtesy of the Three Lakes Historical Society.)

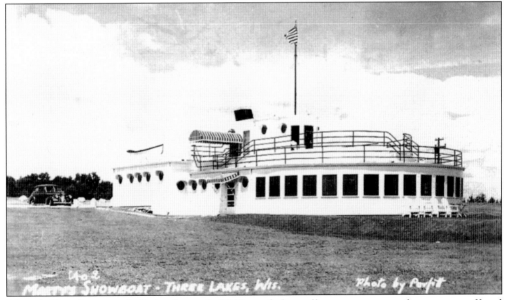

Marty's Showboat was built in the early 1940s and, for well over a quarter of a century, offered entertainment of the highest quality. Carl would not tolerate any "off-color" routines by any performer regardless of status, as he prided himself in offering clean family entertainment. In the summer of 2013, Marty's Showboat was demolished, signaling the end of the Marty story in Three Lakes. Portions of the Showboat were donated to the Three Lakes Historical Society and Museum. (Courtesy of the Three Lakes Historical Society.)

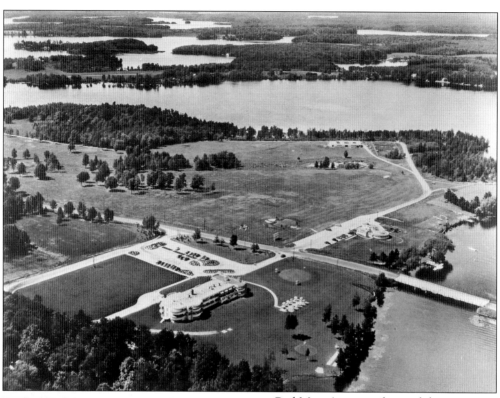

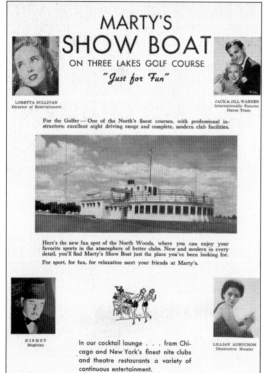

MARTY'S
SHOW BOAT
ON THREE LAKES GOLF COURSE
"Just for Fun"

LORETTA SULLIVAN
Director of Entertainment

JACK & JILL WARNER
Internationally Famous
Dance Team

For the Golfer — One of the North's finest courses, with professional instructors; excellent night driving range and complete, modern club facilities.

Here's the new fun spot of the North Woods, where you can enjoy your favorite sports in the atmosphere of better clubs. New and modern in every detail, you'll find Marty's Show Boat just the place you've been looking for.
For sport, for fun, for relaxation meet your friends at Marty's.

KISMET
Magician

In our cocktail lounge . . . from Chicago and New York's finest nite clubs and theatre restaurants a variety of continuous entertainment.

LILLIAN AUBUCHON
Distinctive Hoosier

Carl Marty's personality and demeanor attracted guests from around the world, and in later years, television and movie personalities as well. The famed striptease artist Gypsy Rose Lee stayed at the Northernaire when she came to northern Wisconsin to fish muskies. Football star Pat Harder and Sen. Gaylord Nelson, the founder of Earth Day, also frequented the resort. The area and the state benefited greatly from the publicity generated by high-profile visitors to the Northernaire. The Chicago & Northwestern Railroad often ran Northernaire Specials to Three Lakes to accommodate the large number of people traveling there. (Courtesy of the Three Lakes Historical Society.)

Carl Marty was not only a talented, warm, and gracious host, he was also a talented advertising man. His "Just for Fun" advertisements, like the one pictured here, traveled through the mail across the country, beckoning people to visit the Northernaire. (Courtesy of the Three Lakes Historical Society.)

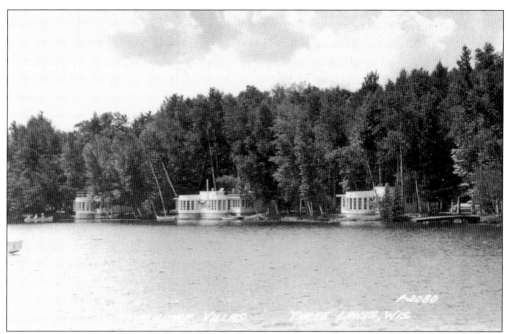

The Northernaire Villas on Deer Lake were constructed before the large hotel complex, and if viewed from the lake in a boat, they appeared to be floating on the water. The Villas afforded guests picturesque views of the lake and wildlife. (Courtesy of the Three Lakes Historical Society.)

Carl Marty's compassion for wildlife, especially for the forest orphans, was well known and brought him fame and recognition throughout the world, attracting the attention of the media as well as notable members of the conservation community such as Marlin Perkins, Sterling North, Sigurd Olson, and Sam Campbell. It was not uncommon for visitors to the Northernaire to see deer wandering through the dining room or bear cubs, foxes, and raccoons wandering the grounds. This was part of the draw of the Northernaire for many people who lived in urban areas and wanted to experience nature in a personal way. (Courtesy of the Three Lakes Historical Society.)

Carl Marty is pictured here with his St. Bernard, Bernese, and two small fox pups in his home at the Northernaire. Bernese and Carl's Cocker Spaniel, Ginger, gained international fame and recognition as foster mothers for many of Marty's "forest orphans." Two books, *Mother Is a St. Bernard* and *Ginger* were stories about the two canine mothers published and sold widely. (Courtesy of the Three Lakes Historical Society.)

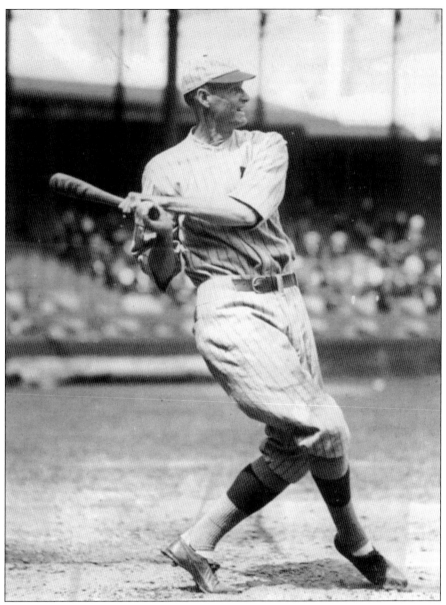

Fred "Cy" Williams moved to Three Lakes from Indiana in 1915. He attended Notre Dame from 1909 to 1913 and played Major League Baseball for 19 years; 6 years with the Chicago Cubs and 13 years with the Philadelphia Phillies. When Fred was traded to the Phillies, his wife, Vada, and their family moved to a house they had built on Range Line Lake in Three Lakes and began to develop a farm. Fred would be gone from the first of March until October. Vada and Fred eventually developed their farm into a self-sufficient operation, consisting of 120 acres of land, a horse barn, dairy barn, and modern milk house. They had a large flock of sheep, 45 head of cattle, pigs, chickens, and a large garden. When Williams retired from baseball in 1938, he farmed full time for a short time and then became involved in the burgeoning construction business in the area, since he had studied architecture at Notre Dame. He designed and built the Northernaire Hotel, along with the Alpine Motor Inn, the Three Lakes Community Building, and the Lake Terrace Estates. (Courtesy of the Three Lakes Historical Society.)

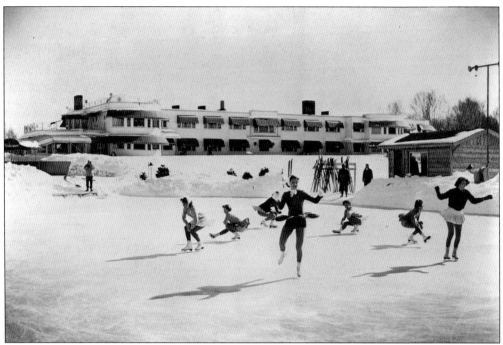

Unlike many of the resorts around Three Lakes, the Northernaire was a year-round vacation destination and guests could enjoy all of the activities common to the different seasons in the Northwoods. From skating to sledding, the Northernaire was a popular destination for families seeking to escape the hustle and bustle of life for a brief respite. Pictured here are the Northernaire's ice-skating rink and large sledding ramp and hill. (Both, courtesy of the Three Lakes Historical Society.)

The outstanding entertainment Marty offered drew full houses from the opening of fishing season through September. Martin Sunshine, known as "Kismet the Mystic" held a lifelong booking tenure at the Showboat, coming here first in the 1940s. Among the most notable entertainers to perform at the Northernaire was Bob Hope, who also appeared in the Three Lakes Fourth of July Parade as grand marshal. (Courtesy of the Three Lakes Historical Society.)

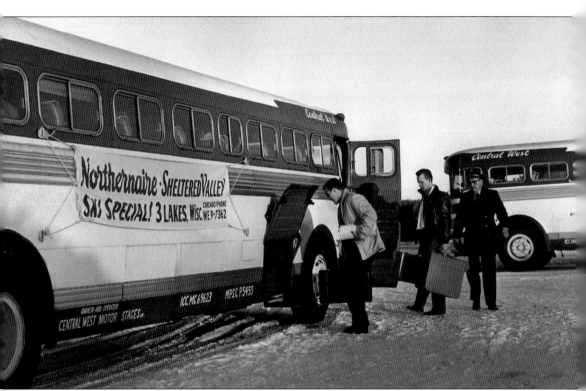

Among the attractions that drew visitors to Three Lakes and the Northernaire was the Sheltered Valley Ski Area, also developed by Carl Marty, located off Military Road on Sheltered Valley Road. After the railroad stopped passenger service to Three Lakes, visitors traveled by bus for weekend trips to the Northernaire and Sheltered Valley. (Courtesy of the Three Lakes Historical Society.)

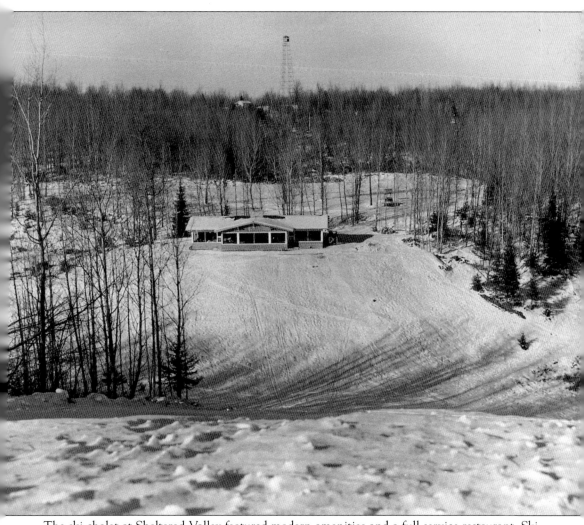

The ski chalet at Sheltered Valley featured modern amenities and a full-service restaurant. Ski enthusiasts could arrive in the morning for a full day of fun on the slopes, take a break for lunch, ski the entire afternoon, and then relax in the warmth of the chalet for dinner. (Courtesy of the Three Lakes Historical Society.)

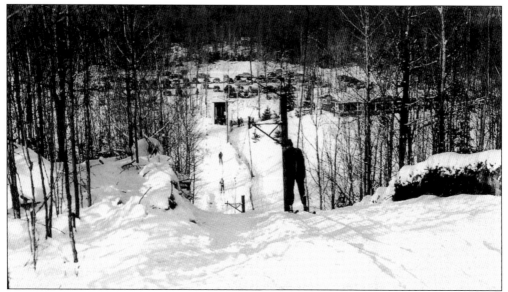

The ski hill at Sheltered Valley was not like modern ski resorts with large chairlifts and extreme drops. The facility featured a simple rope tow to get skiers to the top of the hill. (Courtesy of the Three Lakes Historical Society.)

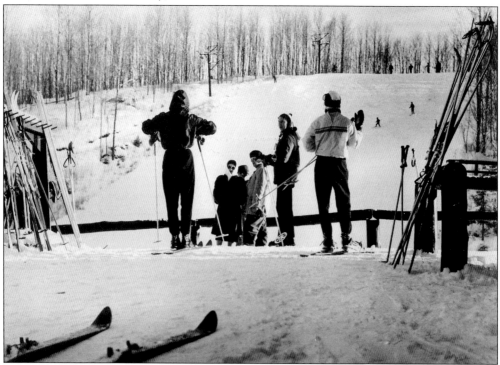

A good number of the visitors to the Northernaire and the Sheltered Valley Ski Area were college students who traveled to the resort on their winter breaks. A male resident of Three Lakes, who occasionally worked at the Northernaire during his younger years, said that one of the perks of the job was being able to see all the girls who came to the resort on ski vacations! (Courtesy of the Three Lakes Historical Society.)

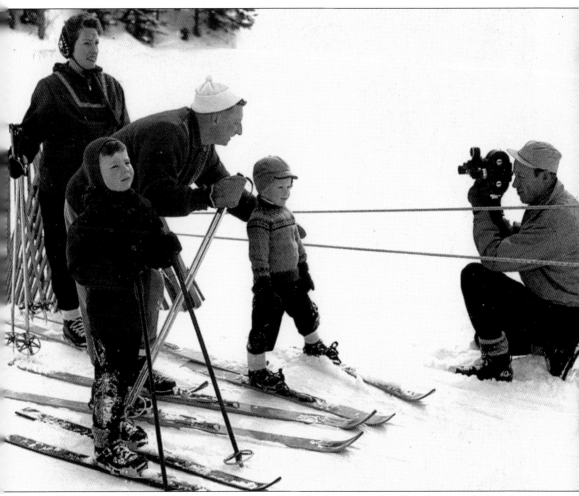

Carl Marty always prided himself on making the Northernaire, the Showboat, and Sheltered Valley family-friendly places where families could come and enjoy quality time together. This picture features a young family at Sheltered Valley being filmed as part of a promotional piece for the Northernaire. (Courtesy of the Three Lakes Historical Society.)

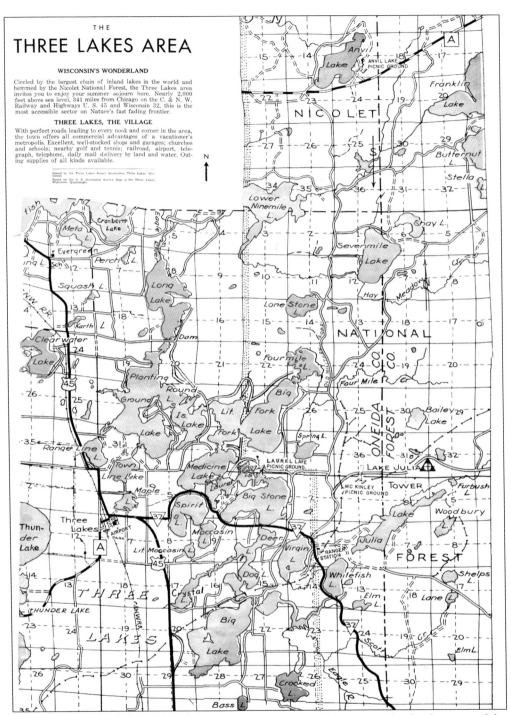

THE
THREE LAKES AREA

WISCONSIN'S WONDERLAND

Circled by the largest chain of inland lakes in the world and hemmed by the Nicolet National Forest, the Three Lakes area invites you to enjoy your summer sojourn here. Nearly 2,000 feet above sea level, 341 miles from Chicago on the C. & N. W. Railway and Highways U. S. 45 and Wisconsin 32, this is the most accessible sector on Nature's fast fading frontier.

THREE LAKES, THE VILLAGE

With perfect roads leading to every nook and corner in the area, the town offers all commercial advantages of a vacationer's metropolis. Excellent, well-stocked shops and garages; churches and schools; nearby golf and tennis; railroad, airport, telegraph, telephone, daily mail delivery by land and water. Outing supplies of all kinds available.

Issued by the Three Lakes Resort Association, Three Lakes, Wisconsin.
Based on the U. S. Geological Survey Map of the Three Lakes, Wisconsin, Quadrangle.

To better understand the effects of the natural landscape of this area on the development of the community of Three Lakes, one only has to look at a map. The early demand of the logging industry led to the damming of the Eagle River resulting in the creation of the world's largest chain of 28 freshwater lakes. Twenty of these lakes are south of the Burnt Rollaways dam on the lower end of Long Lake and called the Three Lakes Chain. (Courtesy of the Three Lakes Historical Society.)

ABOUT THE THREE LAKES HISTORICAL SOCIETY

In 1981, as part of the community's centennial celebration, an active group of citizens from the community organized the Three Lakes Centennial Museum in the basement of the former Chicago & Northwestern Railroad Depot near the intersection of US 45 and Highway A. The museum was an instant success, and it was quickly evident that it needed more space, and an effort began to work with the Town of Three Lakes to locate the museum on property that once belonged to the Frank Johnson family, found adjacent to the town hall and library. The town's original interest in the property was for potential expansion of the town hall, fire department, and library. The Three Lakes Historical Society embarked upon a capital campaign to complete much-needed repairs to the house on the property, which was constructed in the 1880s. The house currently serves as the museum's period house.

Since the relocation of the historical museum to its current location, two exhibit halls have been constructed and contain exhibits that feature local and regional history. The historical society also moved numerous buildings from the area to the grounds and established a pioneer village that features a granary, country store, and one-room log schoolhouse, all of which contain unique artifacts ranging from a copper still used to make "shine," to antique fishing lures, boat motors, antique school desks, and musical instruments.

The historical society remains an active part of the Three Lakes community, hosting the annual Concerts in the Park series, historic demonstrations on the grounds of the museum, a speaker series, a Living History Encounter, and Summerfest, featuring a fish boil and live music. The museum, located at 1798 Huron Street, is open from Memorial Day through the middle of October. Guided tours are available, and the historical society's archives are available to the public for research. More information is available at our website, www.threelakesmuseum.org.

DISCOVER THOUSANDS OF LOCAL HISTORY BOOKS FEATURING MILLIONS OF VINTAGE IMAGES

Arcadia Publishing, the leading local history publisher in the United States, is committed to making history accessible and meaningful through publishing books that celebrate and preserve the heritage of America's people and places.

Find more books like this at
www.arcadiapublishing.com

Search for your hometown history, your old stomping grounds, and even your favorite sports team.